D1254821

Using
Design
Basics
To Get
Creative
Results

BRYAN L. PETERSON

Using
Design
Basics
To Get
Creative
Results

NORTH LIGHT BOOKS
CINCINNATI, OHIO

Since 1985, designer/illustrator Bryan L. Peterson has been president of Peterson & Company, a seven-person design firm in Dallas, Texas.

Peterson's works have appeared in *Communication Arts*, *American Institute of Graphic Arts Annual*, *STA 100*, *Graphis*, *New York Art Director's Annual*, *Print Regional Design Annual*, *American Illustration*, *Type Directors Club Typography Annual*, and other national design publications. Since 1989, Peterson & Company has had 10 annual reports selected by the AR 100 committee to be among the best designed reports in the nation.

Peterson & Company was chosen as one of the top 28 design studios nationwide by *Graphic Design: America in New York City*. In 1986, the Council for Advancement and Support of Education named Peterson "Designer of the Year." In 1992 Peterson served as a judge for the 33rd Communication Arts design annual.

Using Design Basics to Get Creative Results. Copyright © 1996 by Bryan Peterson. Printed and bound in China. All rights reserved. No part of this book may be reproduced in any form or by any electronic or mechanical means including information storage and retrieval systems without permission in writing from the publisher, except by a reviewer, who may quote brief passages in a review. Published by North Light Books, an imprint of F&W Publications, Inc., 1507 Dana Avenue, Cincinnati, Ohio 45207. (800) 289-0963. First edition.

This hardcover edition of *Using Design Basics to Get Creative Results* features a "self-jacket" that eliminates the need for a separate dust jacket. It provides sturdy protection for your book while it saves paper, trees and energy.

Other fine North Light Books are available from your local bookstore, art supply store or direct from the publisher.

02 01 00 99 98 6 5 4 3 2

Library of Congress Cataloging-in-Publication Data

Peterson, Bryan.
 Using design basics to get creative results / by Bryan Peterson.
 p. cm.
 Includes index.
 ISBN 0-89134-651-1 (pob : alk. paper)
 1. Graphic arts—Technique. 2. Design—Technique. I. Title.
NC845.P48 1997
741.6—dc20 96-13571
 CIP

Edited by Lynn Haller and Terri Boemker
Cover and format design by Bryan Peterson
Cover and section photography by Robb Debenport
All Part One illustrations by Bryan Peterson
Art directed by Sandy Conopeotis Kent

The permissions on page 140 constitute an extension of this copyright page.

A c k n o w l e d g m e n t s

Being a graphic designer has taught me that most successful ventures are usually the result of good collaboration. Accordingly, I would like to thank those who have participated in this project.

When authors are chosen by North Light Books to write books of this nature, they are assigned to an editor who has custody of the project from inside the publishing company. From the day Lynn Haller was assigned my proj-ect she has had to bolster her courage to get through the lame humor and sarcasm I have inflicted upon her. She has emerged victorious and in the process, along with providing incisive editorial expertise, has exercised immeasurable patience, persistence and professionalism. She has been the sister I never had and I felt no hesitancy in treating her that way. My thanks go also to Terri Boemker for her editorial contribution and dogged determination, and to all others at North Light who made this book a reality.

I would also like to express appreciation to my wife, Mary Jane, and my family for tolerating the hours I spent away from home while writing and compiling these materials.

This book relies on real-life examples of design that works and would not be what it is without the contributions of numerous talented graphic designers who graciously submitted their work. These friends and peers provided work that makes demonstrating the principles of graphic design easy. I hope you will enjoy the projects you find in this book and the lessons they teach.

Contents

Learn how to balance creative and practical considerations so you can choose the best format for your design — every time.

Line, type, shape and texture are the building blocks for any design. Learn how (and when) to use each of these elements to create great designs.

Using building materials as if they were interchangeable could send the whole structure tumbling down. . . . Here are some principles of design structure that will help you create strong designs that not only hold up, but also stand out in a crowd.

Part 2: Creative Results 78

Intro

Can good graphic design be taught? The ability to come up with a clever concept—the heart of all great design—is difficult to teach, since it relies on the experience and innate ability of the designer. Once an idea is born, however, the skill of effectively translating this idea visually—of executing the concept—can indeed be taught.

YOU NEED A GOOD CONCEPT BEFORE YOU BEGIN

First, focus on generating a good concept—then pick up this book. Even if you have a good idea, it can still be buried under sloppy execution. Poor use of the basic design principles will impede communication of even the best concept; these same design principles,

when used skillfully, will allow the idea to come to the surface. This book's goal is to teach the graphic designer what the basic design principles are and how to use them to convey a message in a design.

1 FIRST, FOCUS ON GENERATING A GOOD CONCEPT— THEN PICK UP THIS BOOK.

The book is divided into two sections.

The first section is an introduction to design basics—an explanation of design elements and principles to help you master the art of visual organization and structure. Each of these elements and principles is explained

verbally as well as visually. Along with the demonstrations defining each element and principle, exercises are included so you can actively learn how each design element works. Don't shortchange yourself by skipping these exercises; doing them can give you a much clearer understanding of the text.

At the end of each subsection is a list of important questions to help you summarize the material you have studied in that particular section. Ask yourself these questions to test your comprehension of the material.

The second section is a demonstration of these design principles in action. Once you learn the organizational skills discussed in the first half of the book, real-life examples will show you how these principles are put into action in actual projects.

While this book alone will not turn you into an expert designer, the lessons taught can establish a foundation that will stay with you throughout your design career. Don't be discouraged if you occasionally forget these prin-

ciples or struggle with some of the concepts. Even as I wrote this book, it was a great help for me to review the very principles that I have

2 THE FIRST SECTION IS AN INTRODUCTION TO DESIGN BASICS; THE SECOND IS A DEMONSTRATION OF THESE PRINCIPLES IN ACTION.

used daily in my profession over the past twenty years; you too may need to review these concepts often to gain a full appreciation of them.

Best of luck to you as you embark on a creative and rewarding journey toward understanding the power of graphic design.

FORMAT COMES FIRST

The page is blank; where do you start? All designs begin with an area of nothing

but space—an empty canvas without color, type, lines, shapes, photographs or illustrations. This space is usually defined, especially in layout, by a perimeter dimension. We'll call this defined space *format*. If you are baking a

YOUR FIRST TASK BEFORE BEGINNING ANY DESIGN IS TO DECIDE THE SIZE AND SHAPE OF YOUR FORMAT.

3

cake, for instance, you first determine what kind of cake you hope to end up with: cupcakes, a single-layer cake or a traditional two-layer cake. This desired end result determines what kind of cake mold you'll use. Selecting the correct mold before you raise a single spoon to add an ingredient is critical to achieving your goal.

In the same way, your first task before beginning any design is to decide the size and

shape of your format. In some cases the format will be predetermined, but when the choice of format is up to you, there will be two specific considerations:

1. The first consideration is creative: What visual impact do you want to have on the viewer and what format would best accomplish this? Sometimes the size of the piece can be the most important creative decision you make. My firm designed an extra-large (13" x 19") issue of *Rough* magazine, the monthly publication of the Dallas Society of Visual Communications. Our intent was to create an impact on designers who too often are required to keep designs to standard dimensions. On the other hand, if I had felt that this project required a classic, sophisticated feel, I might have used a booklet format instead.

Sometimes the shape of a format increases the visual impact of a design. For instance, on page 102 you'll find an example of a brochure that is circular when closed and roughly the shape of a pair of eyeglasses when

open. This piece was designed to sell bifocal lenses. Much of what we do with design creates an immediate impression on the viewer before even a single word is read; format plays a large role in creating the proper mood for a design.

2. The second consideration is practical: Will the final printed piece mail in a particular size envelope or need to meet specific weight and size restrictions set by the post office? Will it eventually need to fit a folder, a binder or some other filing system? If the design is for a poster, what size tube will be required for mailing? Where will the poster hang? How much money do you have in your budget for paper and printing? All these practical considerations will affect your choice of format.

When the format of a piece is considered carefully from both these viewpoints, your design is well on the way to being appropriate for the client. It also has the beginnings of being a design solution that carries a visual impact.

ELEMENTS ARE THE INGREDIENTS

What ingredients go into a cake?

Once the dimensions are established, you'll begin to gather the elements that will be used to compose the design. Just like baking a cake, all of the ingredients must be at your disposal to create the finished piece. If you're

4

THE FOUR PRIMARY DESIGN ELEMENTS ARE: LINE, TYPE, SHAPE AND TEXTURE.

missing the flour, you may end up with something—but it won't be a cake! Likewise, you'll find it very difficult to design anything that is initially missing one of a few essential ingredients. We'll refer to these visual ingredients as *design elements*.

The four primary design elements are:

1. Line. One of the simplest of all the

elements, a line is a great organizer. It can be used to decorate, to create a mood, and to connect or divide other elements for greater comprehension.

2. Type. The written word has been used throughout the ages to communicate. When translated into a type style, it also gains power as an element of visual communication.

3. Shape. Shape is often incorporated in the form of photographs or other types of art. Shape may consist of a block of color or value that adds cohesiveness to a design; a block of text may also be used as a shape.

**WITHOUT THESE ELEMENTS,
A DESIGN IS NO MORE THAN A
BLANK FORMAT.**

5

4. Texture. Just as the texture of building materials is of great importance in creating a structure, visual texture is of great importance in conveying the design message. Texture is

different from shape because it can cover the entire format or define just a particular shape.

Each element is covered in greater detail in chapter two in preparation for building a design. A design can use one or all of these elements, depending on the message (both verbal and aesthetic) that your piece needs to communicate; without these elements, a design is no more than a blank format.

STRUCTURE IS THE RECIPE

Exactly how long do you cook this and at what temperature?

Once a baker has all the ingredients that will go into the cake, the exact order and process used to combine the ingredients will determine the actual success of the finished cake. The baker may decide to frost a half-baked sheet cake, and the cake's physical appearance may even deceive the viewer, but the first slice into it will bring a harsh reminder that things were done out of order.

Likewise, a design will be weakened by the improper organization of elements. The organization of elements in design is called *structure*. The principles of design are the bylaws of proper structure. Good design structure is a result of correct use of principles; the four primary design principles are:

1. Balance. A design can create a mood simply by feeling organized and evenly balanced. Sometimes a design can benefit by a purposely unbalanced feel.

2. Contrast. Use of contrasting elements is a key to designing with impact. Extremes give a design interest and keep it from being static. Through careful use of contrast, a designer can emphasize the message.

3. Unity. Unity may be provided through the way the elements are assembled and through the choice of similar elements to begin with when appropriate. Several

elements—from lines to type to shapes—can be assembled to create a unified look that communicates the message to the viewer. The formal application of a unified structure to a format is sometimes called a *grid*.

6 THE FOUR PRIMARY DESIGN PRINCIPLES ARE: BALANCE, CONTRAST, UNITY, AND VALUE AND COLOR.

4. Value and color. Both value and color can be powerful communicators of mood. They can also provide order to a design and emphasize important elements.

These principles, which are covered in chapter three, allow you to plan and evaluate the arrangement of elements in your design.

Part One

Part One of this book is a basic introduction to the elements and principles that underlie all great designs—the tools and techniques you'll need to construct a design that can stand the test of time.

While I'll introduce each element or principle to you as it works alone, you will rarely use just one element or principle when designing a piece. Just as you probably wouldn't build a house with wood only, so also would you not use, for instance, the element of line by itself when designing a piece.

And while you probably know much of this information intuitively—if a design feels unbalanced, for instance, you might know something's wrong, but not know why—being able to identify why something doesn't work is your first step toward making it work better. And your first step toward getting creative results in your work.

Format

A format is any surface on which the elements that will be used to build a design are placed; structure is the way these elements are placed in the format.

Sometimes format decisions will already be made for you. If you're designing a letterhead, you'll probably have to fit a standard envelope size to avoid paying for the expense of a custom-envelope conversion. If you're designing a magazine, you'll usually need to work with a predetermined size and shape that were chosen with weight and ease of mailing in mind. When designing a direct-mail piece, you'll almost always need to include a direct-response mechanism such as a business-reply card or return envelope—both of which must obey postal regulations.

But when you don't have these kinds of rigid constraints, the possible shapes and sizes of a format can provide a dizzying array of choices. For example, if you are designing a book about postage stamps, should it be a multipaged book just slightly larger than the size of a stamp or a large poster with hundreds of stamps placed side by side? Or how about cutting the book out so the edges reflect the perforated edges of a stamp? In these cases, you can focus on the creative requirements of the design (keeping any practical requirements in mind) to determine which format is the best for your project.

Good design can often be made great by the skillful use of a creative format. Make this decision carefully as you begin your design, and you will often find the rest of the design falls automatically into place.

Format

If you're designing a billboard, you'll be required to work with the size provided by the billboard manufacturer. If you're asked to create a T-shirt, your format has also been predetermined. But for those cases where you'll be the one to decide on the format, you'll need to balance a variety of considerations—both creative and practical.

CREATIVE CONSIDERATIONS

The most important factor in deciding the size and shape of your format is the effect you want your design to have on its audience. Whenever your choice of format is unrestricted, this should be your primary consideration. For instance, have you ever struggled to open a foldout road map while sitting behind the wheel of your car? The experience could lead you to decide there must be a better format for maps used in confined spaces. I recently purchased a map that was spiral bound; this map is so easy to use that I am able to reference it while traveling in traffic. The format is right for its use and for the audience.

Speaking of mood, an oversized brochure may give a design a feeling of luxury or grandeur, while an undersized piece often communicates delicacy or quality. For a younger audience, the shape of the piece may be key. Many children's books are whimsically cut out in the shape of a character in the book or otherwise formatted to hold the attention of a very young audience. For a poster illustrating bridges, for example, a long, horizontal format would add excitement and allow better depiction of the subject matter.

Especially in the beginning, let your imagination run wild. There will be plenty of opportunities for rational thinking as you further qualify the chosen size of the piece on the basis of price, filing needs and so on. But start your planning with the intent to use the format you think will have the most impact on your audience; don't compromise your vision before you even start designing.

PRACTICAL CONSIDERATIONS

Once you've considered what format will work the best aesthetically for your project, you must review more practical considerations, all of which must be balanced in determining what format you end up going with.

Quantity of information. Consider the amount of text and art that you need to incorporate into your piece. What will you need to do to get the reader interested in what you've designed? Will the amount of material fit into the format you want to use? Being tricky for tricky's sake seldom works in effective communication; your format should instead be determined by your message and by the amount of information you have to communicate.

Final quantity and print production. Paper is usually milled to certain sizes and shipped directly to the printer. Papers for web presses usually

come in a continuous roll that will fit the in-line stitchers and binders and that will result in the least paper waste when running standard-size printed material, often 8 ⅜" x 10 ⅞" or some derivative thereof.

Sheet-fed presses employ paper in three standard sizes: 23" x 35", 25" x 38" and 26" x 40". Other sizes are available upon request, but will usually result in a surcharge. Like the web papers, sheet-fed papers are purposely cut to accommodate standard printing sizes, most often 8 ½" x 11". This generally works well for designers, since the majority of typical pieces will fit these paper sizes with minimal paper waste.

The illustration at top right shows how well an 8 ½" x 11" page will fit on the 23" x 35" sheet; you'll be able to fit eight sheets of 8 ½" x 11" paper on one 23" x 35" sheet with very little paper waste. If you designed your piece to be 9" x 12" instead, you would be required to move to a larger sheet of paper, 25" x 38", that would cost slightly more per sheet. If the print run of the piece is substantial, you will have to decide if your budget can stand the bigger sheet of paper. This kind of practical thinking is crucial in the process of deciding size of format. If the print run is substantial and, consequently, the cost of paper is a major factor, I will determine my design format by figuring how my intended size will cut out of the sheet of paper. I may want to design a piece that is 13" square but realize that 13" will not allow me to print more than two pages (see illustration at bottom right).

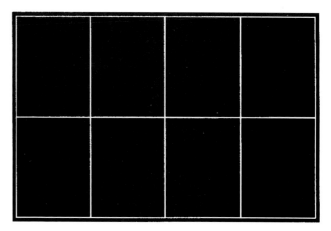

An 8 ½" x 11" page will fit eight times on a standard press sheet of 23" x 35", with very little waste. If your design called for a 9" x 12" page, you would need to move to the next-larger press sheet for printing.

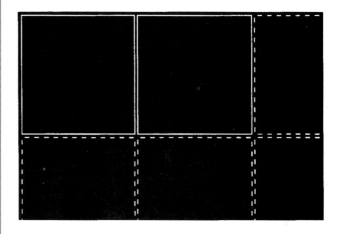

A design that's 13" square will only fit twice on a standard press sheet of 23" x 35". If paper cost is an important consideration, you may be limited to choosing a more standard page size for your piece.

In order to get two sheets to fit on the 25″ side of a 25″ x 38″ sheet of paper, the brochure must be no taller than 12½″ tall. But in reality, you also must leave room for the gripper, which is the device that clamps onto the paper and pulls it through the press, and a little room between the pages, since the brochure may have bleed (a brochure that bleeds is one where the ink goes all the way to the trim).

Taking into account ½″ for the gripper and ½″ between the two pages and from the edge of the page to the edge of the sheet (a total of 1½″), your brochure can be a maximum width and height of 11¾″; that is: ½″ + 11¾″ + ½″ + 11¾″ + ½″ = 25″ (see the illustration at right).

On the 38″ side of the sheet, allowing ½″ between each page and on each end of the sheet, you would be able to fit three pages with ¾″ left over; that is: ½″ + 11¾″ + ½″ + 11¾″ + ½″ + 11¾″ + ½″ = 37¼″.

If paper cost is a factor, the key is to find a way to adjust the size of the piece to allow for the least amount of waste. Sometimes you can find a use for the unused trimmed-off portions of the sheet, such as using the paper to print additional materials (many designers use these trimmed-off portions to print their self-promotion pieces—with their clients' permission, of course). Even printing a smaller-size piece on the sheet with the original piece can result in a cost savings overall. However, this can sometimes complicate the printing process and should only be done with the approval of your printer.

Cost of mailing. Postage rates are based primarily on trim size and weight. As the designer, you'll need to find out what your client's postage budget is for that

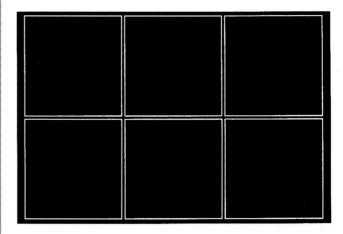

You will often need a little room between pages, and will always need room at the edges of each press sheet (where the gripper handles the sheet). Six pages, each 11¾″ square, will fit nicely on a press sheet of 25″ x 38″.

piece, and then keep that in mind while designing. One way of doing this is to keep an inexpensive postal scale in your office to weigh paper dummies of annual reports and other projects. As you work, you can verify that the trim size (and, if applicable, length) and the paper weight you've chosen—considered in conjunction with the print run—won't cause you to exceed your client's postage budget.

The weight and quality of paper you choose will also affect this cost. Paper is typically milled in several basis weights: 70, 80 and 100 lb. book and text weights, and 65, 80 and 100 lb. cover weights. Paper is calibrated in thicknesses measured in terms of the weight of the paper. The heavier the weight of the paper, the thicker the paper. Other weights are milled for specialty papers. Moving your text weight to a higher level can cause mailing costs to jump to a more expensive category, pushing your postage costs up substantially. Paper is also made in different grades: A

"premium" paper is considered to be the best, followed by number 1, 2, 3 (and so on) grades. The higher the grade, the whiter the sheet and the better it will print. Accepting a lower grade paper will reduce the paper costs—while often not significantly influencing the printability of the sheet. Increasing the trim size of a piece, which increases the amount of paper used for each page, will also increase the bulk of the piece—again increasing postage costs.

While you might be able to build a convincing case that the aesthetics of a project justify an increase in the postage budget, the cost of mailing should be considered when making your final decision on format.

Final destination. Ask yourself how the target audience will use the final piece. Will it be filed in a folder for future reference, placed on a coffee table, hung on a wall, or thrown away after the reply card is torn off and returned? Part of effective communication is to make the greatest possible impact with your design and to persuade your audience to use the piece for as long as possible.

An annual report with an awkward size or shape might have less impact and longevity in the hands of shareholders and analysts. An illustrator's self-promotion brochure that doesn't fit in an art director's file cabinet will not likely be around when that art director is hiring an illustrator. On the other hand, a direct-mail piece with a typical size and format may not attract the necessary attention among the myriad of other direct-mail pieces, and may get thrown away before it's even opened. A poster that is too big to post in limited wall space will not get posted at all; however, a poster that is too small will not attract enough attention among the competing posters on the wall.

BALANCING CREATIVE AND PRACTICAL CONSIDERATIONS

Through experience, you will eventually gain an ability to balance your creative wishes with the realities of cost and practicality. I would suggest you choose a paper manufacturer and ask one of their salespeople to show you the different grades of paper along with the cost per thousand sheets of each. When specifying a paper for an actual print job, you can also have the salesperson give you an idea of how much paper will be required and what the incremental costs will be for adjusting grade, size and weight. With experience, you will find these considerations becoming second nature, and your client will be impressed with your intention to use just the right paper specification to get the job done for the right cost.

AN APPROPRIATE FORMAT ENHANCES ANY DESIGN

The message of a project is enhanced when it is skillfully placed in an appropriate format; a message that is placed in the wrong format for its audience loses power. Remember: The format is the canvas upon which you paint; determining the right nature and size of canvas is critical to the outcome of the final painting.

WHAT TO CONSIDER WHEN DETERMINING A FORMAT

1 What visual impact do you hope this piece will have on the intended audience?

2 How much information will you eventually be expected to place on the format? Does the quantity of type or quality of art dictate that you use a certain proportion?

3 What quantity of the piece is to be produced (that is, what is the print run)? How will the desired format print on standard paper sheet sizes?

4 How will the format impact the cost of mailing? Will using a smaller size or a different format give you a break on mailing costs?

5 What is the end use of the piece? For example, does it need to fit into a particular file folder or be placed in an existing sales kit?

6 What is the visual function of the piece? Will it work better as a multipage brochure or if folded in a certain way?

EXERCISE

EXPLORING FORMAT— The Manifold Possibilities

When you begin to choose a format for your design, let your imagination be your guide. Even a piece that has a finished size of 8½" x 11" can be coaxed into a variety of formats. The illustration at right shows a typical 8½" x 11" page in just a few of the format possibilities; imagine what you could do if there were no restrictions.

Take an 8½" x 11" piece of paper and experiment with various folds. Although you would rarely begin an actual project with an 8½" x 11" piece of paper and fold it to a smaller size, this exercise will allow you to explore ways of folding a sheet that may surprise you. Don't give up after trying the most obvious solutions; force yourself to think like an origamist and to be original. What can you do with other size sheets? Try this same experiment with sheets that are larger, such as 8½" x 14" (legal size), or smaller (even a business card may contain a fold).

However, you may discover that most projects don't require an odd fold. This is fortunate, since generally the more intricate your fold, the more expensive the piece. One reason is that an intricate fold will require an intricate die to allow the fold to fit standard stitching and trimming equipment. In addition, anything out of the range of a standard folding machine may cause your project to require hand-folding—which, depending on the quantity and complexity of your job, could substantially increase the cost. Knowing when a unique idea merits the extra cost it entails, and when it does not, is a skill you will build as you gain experience as a designer.

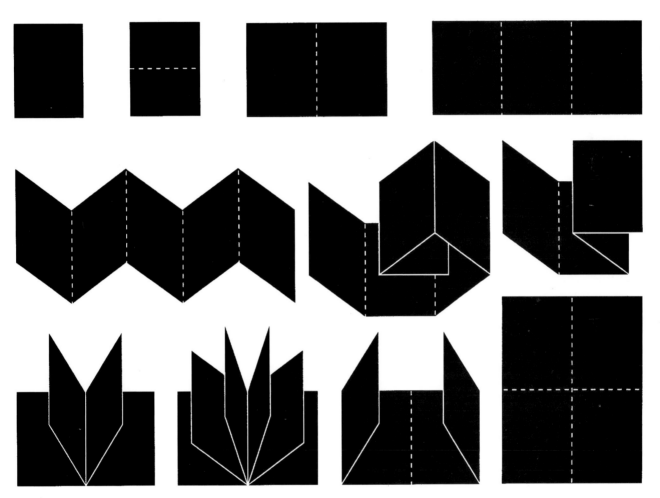

Here are just some of the format possibilities you can consider when designing with standard 8½" x 11" sheets.

Elements

Think of the design process as taking the shape of a diamond. You begin the process at the top of the diamond with the nucleus of an idea you desire to communicate to your audience. At this point you have only the idea. As you proceed down the sides of the diamond, you add in elements—line, shape, type and texture—utilizing basic design principles that will help you best communicate this idea. (These basic principles are the subject of chapter three.) You reach the center of the diamond when you have added in every possible element that could aid communication of that original idea.

Then you begin to dispense with elements that are unnecessary to the idea or weaker than other elements chosen. Finally, you choose to use only those elements you judge to be crucial to conveying your idea, at which time you will have reached the other point of the diamond.

Just as any physical object can be broken down into basic molecules, every design consists of one or more of the four basic elements: line, type, shape and texture. Organized line has the power to direct the eye. The legibility and "feel" of a typeface conveys a meaning on its own, regardless of the content of the text. The shape of a picture (or pictures) on a page can be just as important as the content. And texture is always present, even when it consists of nothing more than the tactile feel of the paper. All parts of any design can be classified as one of these four basic elements, despite the almost limitless variety within an element.

Knowing which elements to include or exclude, which are necessary and which add unnecessary clutter, will strengthen your design ability, and you will soon develop an intuitive gauge to test which elements are crucial to a specific design. Remember, the best designs are done with the fewest elements necessary to communicate the idea.

Line

In chapter one, we established that, much as a painter must first decide the size of his canvas, a designer must first determine the appropriate format for a particular project. Once you've made this decision, you can begin to gather the elements that will, in the end, be used to construct a design. Your goal should be to use as few of the appropriate elements as necessary to communicate your idea with the greatest power.

Let's begin with the simplest of these elements—line. With a single stroke of a pencil (or a computer mouse) you can call this element into play. You can then manipulate the mood of your design or organize your page, depending on the kind of line you've drawn and its placement on your format.

LINES CAN HAVE GREAT VARIETY

At their most basic, lines can add strength to an idea or communicate a feeling. Lines that are fat or thin, long or short, curved or straight, sharp or fuzzy,

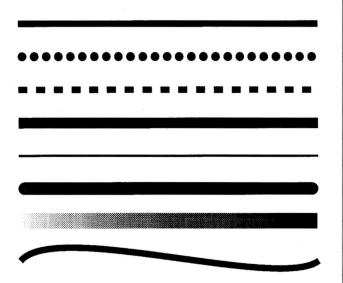

The type of line you choose can add strength to your idea. Lines can be fat or thin, long or short, curved or straight, sharp or fuzzy, or even composed of dots or dashes.

composed of dots or dashes, or with squared-off or rounded corners each have distinct personalities that will bring a unique flavor to each piece in which they're used. At bottom left, you will find illustrations of several possibilities of line.

USE LINE TO CREATE A MOOD

Once you've picked the type of line or lines you'll use, shaping and placing them is equally important in creating a mood. Look at the lines illustrated on the next page. In example A, the simple horizontal line placed centrally in the format feels comfortable and calm surrounded by white space; when that same line is placed off-center and at an angle, as in example B, a more active feeling is suggested. Horizontal lines typically communicate a restful feeling, while vertical lines denote organized activity (as in example C) and angular lines can add tension and random action to a design. A curved line, like virtually every line, can be used to establish direction, but in addition it gives the design a

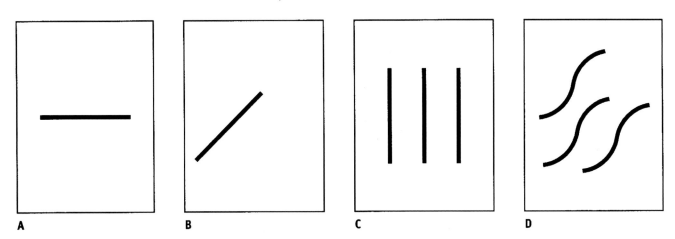

In example A, the placement of the line creates a calm mood. While B shows the same line, its position and placement suggest a more active feeling. The lines in C suggest organized activity, while the curved lines in D give a flowing feel.

flowing or moving feel (as in example D).

Who can't appreciate the beauty of soft rounded hills in a pastoral landscape? Contrast that with the hard angular feel of mountains jutting from the ground. Line is responsible for the mood of these two contrasting natural settings. A dashed line on a road indicates the proper lane divisions; this dashed line also indicates permission to pass another vehicle, while a solid line prohibits passing. As you start to appreciate the influence of line, you can't help but notice the parts lines play in our everyday lives.

USE LINE AS AN ORGANIZER

When used appropriately, line is a powerful element that can be employed not only for communication, but also for organization. Lines can be used on a page either to join related elements or to divide unrelated ones. As an exercise, open a copy of your favorite magazine and notice how often lines are used in this way. For instance, notice how they're used to join an article and an accompanying photograph in a box. Also notice how often lines are used to frame a photograph, separating it from the type or other graphics surrounding it, or to separate a sidebar from the rest of a page.

Borders—which are nothing more than lines organized around shapes—also qualify as organizational tools, even when they're used to border an entire page. The cover of *National Geographic*, for example, has established an identity that uses a yellow border; this border is really just a line effectively used for identification and power.

Line is the best friend of a grid. Grids are created on the format to give the designer a designated position for type, shapes, textures or other lines. Often type is placed in organized columns on the page to cue the reader to the flow of the text. To strengthen this grid, actual grid lines are sometimes drawn to designate columns or position of art. As a bonus, when these grid lines appear throughout a brochure or magazine, the piece is given a rhythm that adds structure and unity to the design.

USE LINE TO ADD TEXTURE

Especially in illustration, line can be effective in adding texture to your artwork. Take a look at the poster by Lanny Sommese on page 81. Notice how the entire poster is made up of lines—and especially how the background texture is established through the use of line. The feeling of this particular line—hand drawn with a pen in a loose style—also lends a specific feel to the poster. Imagine how different this poster would look if the lines were rigid and controlled.

WHAT TO CONSIDER WHEN USING LINE

1 Have you chosen lines that convey an appropriate mood or strengthen your idea in some way? Have you given thought to the full array of possible types of line you might use (thick vs. thin, sharp vs. fuzzy, wavy vs. straight)?

2 How do the lines you have chosen organize your design? Are you using line to connect or separate other elements on the page? Do these lines actually lead the eye in the ways you intend? Have you thought of using a border as a design element?

3 Are you able to use lines to establish a grid? That is, are lines used to support columns of type or photographs, and do these lines appear in the same position from page to page, giving your design structure and unity? (An underlying grid can be quite valuable, even if the grid lines themselves are invisible in the design.)

4 Does your use of line create texture in your design or illustration? Does this texture reinforce your idea?

5 Are you using line wisely? Are there lines in your design that are freeloading on the design—not performing a service of any kind? (Remember to remove any lines from your design that are not contributing to your idea; unnecessary lines will serve only to distract from your idea.)

EXPLORING LINE—Cutting the Diamond

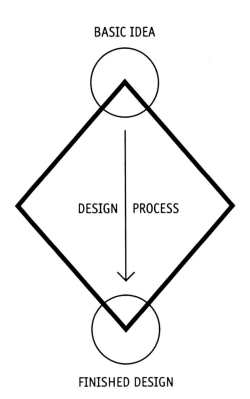

BASIC IDEA

DESIGN | PROCESS

FINISHED DESIGN

Think of the design process as being diamond-shaped. You start with an idea, add in all the elements you can think of to express that idea, then narrow your focus and eliminate all but the strongest elements to create your finished design.

The ability to distill a design to its most powerful form using simple elements is a key to successful design.

In the introduction to this chapter we compared the design process to the shape of a diamond. You begin with only an idea—the top point of the diamond—then expand into a wider and wider shape as you add in all possible elements for expressing that idea. Finally, you begin to eliminate weaker elements and to narrow your focus once again until your design is composed only of the strongest elements that convey the original idea.

For example, suppose you're trying to illustrate the idea of a "gathering" using simple elements such as lines, type, shapes and textures. Begin by asking yourself if you want to communicate this idea with just a few simple lines or if you'll need to add type, shapes or textures to communicate the concept effectively. You may want to start with lines only; you could decide to start out with type, shapes or any other element.

Add elements to the format until you feel that all possibilities have been explored. At this point, your design may seem cluttered with lines, shapes and so on. You have effectively reached the midpoint of the diamond shape, having added in and considered every possible element that could strengthen the idea. Now try removing one type of element—such as all the shapes. Did doing this weaken or strengthen the idea? In this case, you might decide that the shapes you've introduced only confuse the concept, and that the idea of a gathering can be communicated with the use of only a few strategically placed lines.

What if you remove lines? How many lines are necessary to communicate the idea? Can the idea of a gathering be communicated using only a few strategically placed lines? When do you seem to have one line too many?

Since a gathering must involve at least several pieces, and should include the concept of "coming together," you may decide that you could use as many as thirty lines to

give direction to the gathering and a feeling for the idea. But could you illustrate the idea with just twenty lines? Follow this process until you have only the minimum number of lines, shapes, type or textures you need to communicate the idea most strongly. The finished design in the example below consists of twenty strategically placed lines that effectively communicate "gathering."

You also find yourself at the bottom of the diamond, having eliminated all but the elements necessary to the design.

As you eliminate elements, you travel down the diamond shape to the end point where the idea is strong and communicated with just the right kind and number of elements.

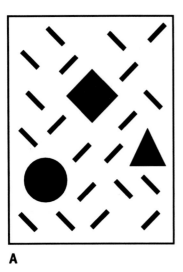

A

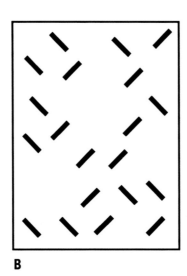

B

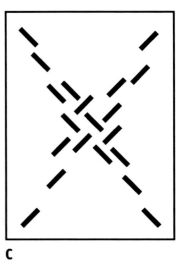

C

How would you illustrate a gathering? First, add in all the elements you can think of that help convey the idea (example A). Then, begin to eliminate elements you don't need (example B). Finally, keep (and arrange) the minimum number of elements you need to convey your idea (example C).

Type

Type is a crucial element for any design in which it appears—and it is used in many designs. Type is perceived by the viewer in several ways simultaneously: as text to read, as shape, and as a purely visual element in which the letterforms themselves convey a feeling or a meaning. Consequently, learning to use type well is one of the most important skills you can develop as a graphic designer.

Using type well means using it appropriately to communicate, taking into consideration the various ways it will be perceived by the viewer. When you've used the character of a visual symbol—the typeface itself—to convey the meaning of the written word the symbol represents, you've effectively used type to solve a problem. When type is used well, it may even stand alone—without an accompanying illustration or photograph.

When type is used badly, however, it can actually interfere with the intended message.

TYPE CAN CREATE A MOOD

Let's look first at a single character of type to understand the power type can give your design. When set in various faces, even a single letter—such as a lowercase *a*—can evoke different feelings, depending on the design of the typeface. When the letterform is flowing and curvaceous, the feeling conveyed is softer than the feeling communicated when the letterform is angular and hard-edged. A whimsical letterform will convey a lighthearted mood; one that is elegant will communicate sophistication.

As another example, choose two words with contrasting or even opposite meanings, such as "peace" and "war". After seeing each of these words in the various typefaces (see next page), which face do you think is most appropriate to the meaning of each word?

While the Helvetica typeface on the top is adequate to communicate either idea, the words take on added meaning when set in a script such as Snell Roundhand, or a bold, square, serif typestyle such as Machine. Notice how jarring a completely inappropriate typeface can be.

Often, two or more contrasting typefaces can be

Even a single character of type can evoke different feelings, depending on the design of the typeface in which it's set.

used compatibly in the same design. In fact, interest is generated by the use of contrasting typefaces. In a magazine layout, for example, a serif face can be used in conjunction with a sans serif face—one for body copy and the other for sidebars, captions or headlines.

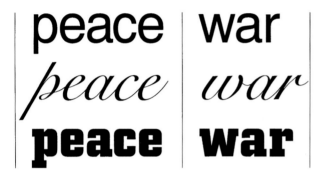

Choice of typeface depends, in part, on the content of the text. While the Helvetica typeface on the top is adequate to communicate either idea, notice how the words take on an added meaning when set in an appropriate typeface. (Also notice how jarring an inappropriate type-face can be.)

TYPE HAS MANY VARIATIONS

Typefaces are typically divided into four categories: serif, sans serif, display and script.

Serif faces get their name because the characters have short lines stemming from the upper and lower ends of the strokes of a letter, causing some of the letters to resemble the serif of an architectural column. (Consider an uppercase *T* set in Times Roman, for example.) And they have been around since ancient times. Serif faces are most commonly used for body text because they are extremely legible.

Sans serif faces lack serifs, thus the name (*sans*

is derived from the Latin *sine*, or *without*). Sans serif faces were especially popular in Swiss design because of their simplicity and straightforwardness; they generally have a more modern feel than serif faces. Sans serif faces are used for many kinds of text, and are often used for headlines or captions.

Display faces derive their name from early-1900s advertising when a particular face was needed for a headline only to "display" a product. The idea of using a display face in body copy was unthinkable—and is still inappropriate in most cases—because these faces tend to be very ornate.

Script faces are derived from penned calligraphy and are most commonly used to convey elegance and sophistication. A plethora of script faces exist; they are most commonly used on wedding invitations.

Typeface choices in all of these categories are plentiful.

When choosing a typestyle for your design, keep in mind that one of the most important virtues to possess is restraint. Some typefaces are simply too decorative for most purposes, and while you might believe you are enhancing communication when you choose one of them, you may be unnecessarily complicating your design.

In the example on the top of the next page, you might at first have expected a more decorative face to be the better choice, but note how a simpler typeface can often communicate with greater power.

The computer has also given the typographer the option to distort the type horizontally and vertically, or to attach an effect, such as dimension, blurring, outlining or any number of other distortions, to the type. I believe the use of these distortions should be judicious

THERE IS NO
EXCELLENT BEAUTY
THAT HATH NOT SOME
STRANGENESS
IN THE PROPORTION.

*THERE IS NO
EXCELLENT BEAUTY
THAT HATH NOT SOME
STRANGENESS
IN THE PROPORTION.*

Some typefaces are simply too decorative for most purposes. At first glance, you might think a decorative face would be a good choice for this sentiment, but notice how the simpler typeface is actually more powerful.

and respectful of the inherent design of the letterform. Inappropriate distortions distract the viewer and appear gimmicky. Effective use of distortion depends on the desired feel of the design.

In the example at bottom right, the distortion of the type is what makes the idea work.

CHOOSE AN APPROPRIATE TYPE SIZE AND FONT

Once you understand the power of a single character of type and how the choice of typeface can be an extremely powerful influence, you're ready to use type as a design element. There are no hard-and-fast rules for how large or small your type should be in the format; generally speaking, common sense will dictate font size.

Consider the audience and the nature of the project. Type that is too small may be bothersome to read. Type that is too large may overpower the other elements or take away sophistication or elegance. If you are designing a booklet that includes technical data, form will follow function; an easy-to-read typestyle set in an easy-to-read size is required. If you are

In this example the distortion of the type makes the idea work, but inappropriate distortions can distract the viewer and appear gimmicky.

designing a poster that has a single word as a message, such as "death," and you want the poster to shock the viewer, you may want to use a very bold face and a large typestyle to achieve a bold effect. But if, on the other hand, the idea is to communicate the sacredness of death, you might want to choose an altogether different face.

The example below shows how the same word set in two different typefaces can communicate two different messages. Notice also how the additional use of line strengthens the concept in each design.

The same word, when set in two different typefaces, conveys two different messages. Unlike the example on page 32, using the words "war" and "peace", either of these faces might be appropriate, depending on what aspects of death you want to communicate.

TYPE CAN BE USED TO CREATE SHAPES

When many words are used together in text, you'll have an additional aspect of the type to deal with; this grouping of text type is often called *body copy* because it begins to take on a shape in addition to the given form of each letter or word. The examples below illustrate how the same body of copy can have a different effect depending on the typestyle, type point size and configuration of the text.

The skilled designer has a feel for how large or small type should appear for a particular design. Black type that is set small will give the appearance of being a massive gray shape on the page. This may be desirable if the goal is to relieve the eye from an otherwise busy design. But more often, this gray mass of type is unattractive to the reader and may make the design feel ominous.

Type is a crucial element

Type is a crucial element for any design in which it appears, and it is used in so many designs. Type is perceived by the viewer in several ways simultaneously – as text to read, as shape, and as a purely visual element, in which the letterforms themselves convey a feeling or a meaning. Consequently, learning to use type well is one of the most important skills you can develop as a graphic designer.

Using type well means using it appropriately to communicate, taking into consideration the various ways it will be perceived by the viewer. When you've used the character of a visual symbol – the typeface itself – to visually convey the meaning of the written word that the represents, you've effectively used type to solve a en type is used well, it may even stand alone, ccompanying illustration or a photograph. e is used badly, however, it can be riate to the communication that it interferes ended message.

Type *is a crucial element*

Type is a crucial element for any design in which it appears, and it is used in so many designs. Type is perceived by the viewer in several ways simultaneously – as text to read, as shape, and as a purely visual element, in which the letterforms themselves convey a feeling or a meaning. Consequently, learning to use type well is one of the most important skills you can develop as a graphic designer.

Using type well means using it appropriately to communicate, taking into consideration the various ways it will be perceived by the viewer. When you've used the character of a visual symbol – the typeface itself – to visually convey the meaning of the written word that the symbol represents, you've effectively used type to solve a problem. When type is used well, it may even stand alone, without an accompanying illustration or a photograph. When type is used badly, however, it can be so inappropriate to the communication that it interferes with the intended message.

TYPE CAN BE TIMELESS OR TRENDY

Remember that every character of every typeface was at one time dreamed up by a designer. Many faces are ancient and have been refined continuously over the centuries; the best of the old faces have stood the test of time because of their usability and readability.

Other, more faddish faces (often display—or decorative—typefaces) were designed to achieve a certain effect. For instance, Blippo was designed in the 1960s and was quite popular, but in the 1990s it is considered to be a face that catered to the fads of that time; you may be able to use Blippo when designing a "retro" piece—for instance, a poster for a dance with music from the 1960s—but you would never use it for body copy in a textbook. Caslon, on the other hand, has been around for a century and continues to be popular today because of its classic style.

In other words, there are both timeless and trendy typefaces. Only through experience and trial and error can you build a palette of typefaces that not only will provide any feeling you wish to communicate in your design, but will stand up to the test of time. You will also find you can eliminate from your palette those faces that hinder communication.

Your tastes will constantly evolve over time. Don't be dismayed if a typeface that you currently feel is useful becomes useless to you in years to come. This is a result not only of a change in fads but also a refinement of your own tastes.

> Type Can
> Be Timeless
> or Trendy

> Type Can
> Be Timeless
> or Trendy

Caslon 540 Roman, the typeface used on the left, will probably look current fifty years from now, while Lunatrix Light, the typeface on the right, will have a distinctly '90s feel.

WHAT TO CONSIDER
WHEN USING TYPE

1 What typestyle will best communicate the feeling of your message? Does your typeface harmonize with or detract from your message?

2 Will two or more different typestyles be more effective in displaying the concept than one? (Consider combining a serif face with a sans serif face, for example.)

3 What size type will best convey the idea of the design? Is the size appropriate for the audience? Does it complement the other elements?

4 Is the type properly placed in the format to have the most impact on the reader? Are the shapes of the body copy pleasing or are they unattractive?

5 Is the typeface one that needs to hold up well over a period of time, or is a more current typeface a better choice?

EXERCISE

EXPLORING TYPE—Secrets of Kerning

Proper spacing of the characters in typeset words is ultimately the responsibility of a competent designer. Type in body copy is not normally custom-spaced by the designer, since most page layout programs (or other typesetting equipment) automatically set up pleasing spacing. But when using larger type—such as in a headline—

it is often necessary to individually adjust the space between letters; this is known as *kerning* the type. It's especially important in certain combinations where letters don't automatically fit together well. Over the years, I've heard of several methods that can be used to achieve pleasing letter spacing; following are two that have worked well for me.

1. The sand method. Imagine that you are going to pour an equal amount of sand between every two characters of type. The bigger the initial gap there is between two characters, the closer they will have to be moved together to accommodate the same amount of sand. For example, an uppercase *C* and an uppercase *X* would create a sizable

letter spacing
letter spacing

Before and after

LAND

A ligature of the L and A

Good letter spacing can make a big difference, as this "before" and "after" sample shows. Sometimes a very large space between letters can be best closed by a ligature.

gap between the two letters. Conversely, if you have two characters that fit together snugly, such as an *I* and an *H*, you may have to separate them a little to accommodate the same amount of sand. In certain extreme cases, such as when an *L* is placed next to an *A*, a *ligature* may be required; this is where the left serif of the *A* will overlap the *L* to close up the space (see illustration on page 36).

2. Three-letter method. Look at only three letters at a time of the word you wish to space and ignore, for the moment, the rest of the characters. For example, as in the illustration below you would only view the characters *l, e* and *t* of the word *letter*. When these three letters look evenly spaced, next view only the characters *e, t* and *t*. Then, space the letters *t, t* and *e*, and so on.

letter spacing
let
let
ett
ett

One way to approach letter spacing is the three-letter method. By looking at a word just three letters at a time, you can focus your attention on small parts of the word in turn, until all of the letters are pleasingly spaced.

Shape

Shape is another element that can be used alone, or in conjunction with line and type, to help communicate the concept of a design. Shape can be defined as any element that's used to give or determine form.

Shape can exist as a design element all by itself, without the aid of line or type. Most flags are designed with nothing but shapes. Even if you remove the color from the American flag, the design survives intact. Likewise, many fabric patterns are the result of designing with shapes; they effectively convey a style and mood, usually without the benefit of type. When shapes contain decorative illustration, such as floral patterns or other subject matter, additional interest is added.

Most flags are designed with nothing but shapes. If you remove the color from the American flag, for example, the design survives intact. When shapes contain illustrations, or any subject matter, additional interest is added.

SHAPE CAN BE CREATED IN A VARIETY OF WAYS

A photograph, illustration or block of shading can provide shape. If you're designing a poster and have used line and type to communicate, but still feel the need to strengthen the idea through the use of art, any art you add will also add a shape. So photographs and other types of art will always impact your design in two ways simultaneously: first as shapes and, second, through the content of the art.

When a single shape housing a photograph or illustration is added to a format—with or without type or line—the format instantly takes on a conceptual theme based on the content and shape of that piece of art. Therefore, it stands to reason that shape can be the strongest of elements, because the subject matter of the shape will automatically either contribute or distract the viewer from the intended idea. Consequently, it is critical that shape in the form of a photograph or

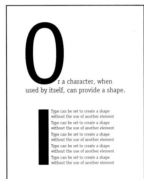

Both line and type can also serve as shapes on a format. Lines can be used by themselves to create a border or another shape, and even a single character of type can provide a shape.

illustration be used carefully.

Both line and type can also serve as shapes on a format. A single line can be prominent enough to create a shape, such as in the example above; a group of four lines can become a border that imposes a shape on the format. Type can be set into a block of text that also composes a shape. The illustrations above, and on page 40, all use line or type to create shape.

SHAPE CAN SUSTAIN INTEREST

Shape is often used to hold the interest of the viewer. On a page that is heavy with type, shapes—in the form of photographs, illustrations or simply colored areas or textures—can serve as a relief to the reader. Shapes can serve to break up the copy into smaller segments, which psychologically allows the reader to read in smaller pieces.

Shape can also be used to separate and organize, and can hold the viewer's attention that way. For example, type can be put into a shape and placed within a larger block of text. This is often referred to as a sidebar. Sidebars typically deal with a subtheme of the main story, but are just as valuable visually because they add variety to the page.

When a format is highly structured or necessarily loaded with type, color shapes can be useful to give the page a freer form and add interest. In the example below, the same page of type is shown with and without color boxes. Clearly, the added shapes draw the eye to the layout on the right. Be careful not to use shape indiscriminately. You will add strength to your design if you can give the page added meaning by the use of shape—instead of using shape simply to decorate.

Type is a crucial element

Type is a crucial element for any design in which it appears, and it is used in so many designs. Type is perceived by the viewer in several ways simultaneously – as text to read, as shape, and as a purely visual element, in which the letterforms themselves convey a feeling or a meaning. Consequently, learning to use type well is one of the most important skills you can develop as a graphic designer.

Using type well means using it appropriately to communicate, taking into consideration the various ways it will be perceived by the viewer. When you've used the character of a visual symbol – the typeface itself – to visually convey the meaning of the written word that the symbol represents, you've effectively used type to solve a problem. When type is used well, it may even stand alone, without an accompanying illustration or a photograph.

When type is used badly, however, it can be so inappropriate to the communication that it interferes with the intended message.

Type is a crucial element

Type is a crucial element for any design in which it appears, and it is used in so many designs. Type is perceived by the viewer in several ways simultaneously – as text to read, as shape, and as a purely visual element, in which the letterforms themselves convey a feeling or a meaning. Consequently, learning to use type well is one of the most important skills you can develop as a graphic designer.

Using type well means using it appropriately to communicate, taking into consideration the various ways it will be perceived by the viewer. When you've used the character of a visual symbol – the typeface itself – to visually convey the meaning of the written word that the symbol represents, you've effectively used type to solve a problem. When type is used well, it may even stand alone, without an accompanying illustration or a photograph.

When type is used badly, however, it can be so inappropriate to the communication that it interferes with the intended message.

At left, type alone seems less organized than at right, where solid shapes have been used to reinforce the type's organization.

SHAPE ORGANIZES

Much of design is nothing more than the organization of elements to support a concept. But the way those elements are organized can make all the difference. For example, type and shapes placed randomly on a page can be confusing, but solid shapes behind type can serve to organize the body copy.

Text type itself will usually take on a shape when it is set in a column or box; it is not always necessary to place type within a shape that consists of a line or a shaded area. Sometimes the shape of the type itself is enough to break the page up and hold the interest of the reader. When designing a layout, ask yourself if the design is better without the addition of a box to hold the type. Remember our earlier lesson concerning the diamond concept, and eliminate any unnecessary elements in your design.

SHAPE CAN BE A CONCEPTUAL TOOL

Through the use of shape you can lead the viewer's eye through the design to help that viewer understand the concept. The example below shows the metamorphosis of a circle into a square. Notice how your eye automatically wants to find the beginning and the end of the design, following the steps of the transformation. Rarely will your eye be drawn to the middle of a design first. Likewise, in a layout that consists of many elements, the eye will search for an object or shape that seems to give the design a place to begin and will follow the design to the end point in an effort to under-

Type is a crucial element

Type is a crucial element for any design in which it appears, and it is used in so many designs. Type is perceived by the viewer in several ways simultaneously – as text to read, as shape, and as a purely visual element, in which the letterforms themselves convey a feeling or a meaning.

Using type well means using it appropriately to communicate, taking into consideration the various ways it will be perceived by the viewer.

When type is used badly, however, it can be so inappropriate to the communication that it interferes with the intended message.

When you've used the character to visually convey the meaning of the written word that the symbol represents, you've used type to solve a problem.

Consequently, learning to use type well is one of the most important skills you can develop as a graphic designer.

Depending on its configuration, sometimes the type itself is enough to create a shape that will hold the viewer's attention.

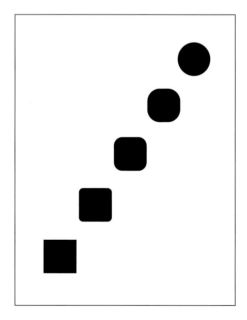

Notice how your eye automatically wants to find the beginning and the end of a design, and will follow, in order, the steps of a transformation. Because of this natural tendency, shape can be used to lead the viewer's eye.

stand it. Sometimes the eye will be drawn by the largest element, sometimes by the most brightly colored or, in a layout with many squares but only one circle, by the shape that differs from all the others.

Have you ever considered that type is nothing more than shapes that have symbolically taken on special meaning when placed in a specific order? We learn to find the first letter of the word and read the symbolic shapes in proper order to make sense of the message.

As human beings, we are drawn to shapes that we identify with. A picture of another human being is usually the first element that the eye will go to when viewing a layout. A photograph or illustration of any subject matter will also effectively attract the eye. Large type is another element that attracts the eye, although it is not as alluring as a visual. The last thing to draw the eye is usually a massive shape consisting of small type. As an example, when you look at a copy of the Declaration of Independence, what attracts your eye? Is it the body copy, the large type at the beginning or the signatures? You will probably find that you zero in on the large type at the beginning of the document first, then on the signatures at the end—some of which have more visual appeal than others—and only then do you look at the body copy.

Since we're so used to seeing shapes of all sorts and to interpreting their meaning in everyday life, it's easy to take the importance of shape for granted in our design work. But learning how to use shape to hold the attention of the viewer and to lead the viewer's eye through your design is important. Train yourself to ignore the content of the shapes you use and to look at your designs with an eye that is sensitive to the shapes created by different elements.

WHAT TO CONSIDER WHEN USING SHAPE

1 What kinds of shape will be most appropriate to your concept? Will you use photographs? Illustrations? Shaded areas?

2 How can the shapes you're using be made to sustain the viewer's interest? Will shapes be used to break up blocks of text or to unify other elements?

3 What shape is your text taking? Does it make sense to break your text up into different shapes in order to improve the communication of your message? For example, if your body text is the form of one wide column, would it help to break it into three columns? Would the addition of a sidebar aid readability?

4 Can shapes help you lead the eye through your design? When you look at your design, where does your eye go first?

5 Have you successfully removed any shapes that distract from the idea of the design? (Shapes are most powerful if they support the concept and give the page added meaning. Shapes can actually weaken a design if used simply as decoration.)

EXPLORING SHAPE—Getting Into Shape

A designer must learn to look beyond the subject matter of the shapes used and to understand that the shapes themselves will either help communicate or distract from communication.

For this exercise you will need one or more magazines, several sheets of tissue paper and a thin black felt-tip marker such as a Sharpie.

Open the magazine (or magazines) and find four opening feature spreads or four advertisements.

Place a sheet of tissue paper over a layout and tape it down at the corners. You might have to use several sheets of tissue paper, since the idea is to begin to see the shapes on the page without being distracted by their subject matter.

Now, as in the illustration above, use the felt-tip marker to draw a line around the various shapes represented on the page. You may even elect to follow the contour of the headline as you bounce over upper- and lowercase letterforms.

What do you notice about the dominant shapes on the layout? Which ones jump off the page and which ones seem to play a minor role?

Do the same with each of the four layouts and then compare their strengths and weaknesses. Which one seems to be the most successful? Which one has shapes that hold your interest? Which layout uses the most varied shapes? Does it seem to be an asset to the layout?

Texture

The fourth and final element of design that we'll discuss is texture. Texture can be defined as an object's visual or tactile surface characteristics and appearance, or as something composed of closely interwoven elements (such as a woven cloth). In graphic design, texture is most often used as a secondary element to reinforce an idea, rather than as the primary element to communicate a concept.

THE MANY USES OF TEXTURE

Texture can be used to fill a shape or as an overall background for type and line to create a particular mood for a design. Even when texture isn't added intentionally, the design will contain some form of texture, such as the texture of the paper or of other materials used.

Contrasting textures that are not normally seen together can create an interesting feeling. For example, a close-up photograph of blades of grass placed against a photograph of chrome plating can create an odd, but intriguing, look.

The example of the Mothers Against Drunk Driving annual report on page 109 shows how texture—in this case, metallic and canvas textures—can be used effectively to communicate an idea. The steel binding of a ledger was photographed and placed next to a

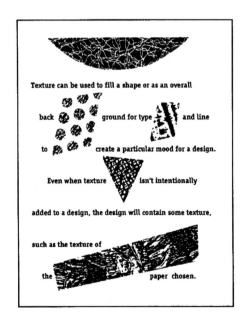

Texture can be used just to fill individual shapes, or it can be used as an overall background for type and line to create a particular mood for the whole design.

scanned canvas texture to give the piece the feeling of a ledger.

With the current ease of importing art into computer layout programs, designers are finding an unlimited number of uses for texture in their designs. Virtually any texture can be scanned into a program like Photoshop and incorporated into a design. Sometimes, instead of printing on an uncoated paper stock, the texture of the uncoated stock is scanned, imported and printed on a coated paper stock. This way, the designer will have photographs that retain the density and detail of being printed on a coated paper, with the additional textured look of an uncoated paper.

TEXTURE IN EVERYDAY LIFE

To better understand the use of texture as a design element, think of some of the uses of texture in your everyday environment and how these textures can communicate a mood.

When an interior designer begins to design the look of a room, the texture of the walls is of primary importance. For example, if the room has a Southwestern decor, the designer may specify a stucco finish for the walls. Something more contemporary might call for walls of exposed brick or cement. A nursery will probably be done in pastel colors and soft fabrics, whereas a den might seem to call for warm-colored walls, bookshelves and hardwood floors.

Have you ever been intrigued by the textures—both natural and man-made—that can be seen from an airplane? Flying over fields of wheat that are ready for harvest, you not only see the texture of the plants as a whole, but also the individual rows that create rhyth-

mic patterns. Even houses and roads create interesting geometric patterns. As soon as you notice the textures that exist on nearly every surface, you'll begin to develop an awareness of the textural possibilities that can powerfully reinforce the concept of your design.

FINDING APPROPRIATE TEXTURES

Where do textures come from and what varieties are available? As mentioned previously, the first texture a design has is often the paper you use. Recycled and handmade papers, in particular, may have a noticeable texture or may contain flecks (another layer of texture); coated papers impart a slicker feel to a piece than uncoated papers do.

The background of a piece of art, such as a photograph or illustration, may contain a texture. And with the use of a photocopier or a scanner, you can easily manipulate photographs or artwork to create an infinite variety of textures to enhance your design. If you have access to a photocopier that permits you to enlarge your original, experiment with enlarging different common textures, such as a crumpled paper bag or an old pair of blue jeans. The copier will remove the midtones and convert all tones to either white or black. Notice how interesting these everyday textures can be, and make a mental note of which ones might work in a future design.

TEXTURES AVAILABLE THROUGH THE PRINTING PROCESS

There are various textures available through printing processes. Along with standard offset lithogra-

phy, there is silkscreen, embossing, debossing and foil stamps, as well as engraving and its less expensive cousin, thermography. There are also the printing methods of the past, such as letterpress.

Silkscreen involves creating a negative mask for your art and pushing ink through a mesh screen to create vivid color and an opaque quality not available with offset lithography; when silkscreened, solid areas of color have a velvety texture that can enhance a design.

Embossing and debossing involve creating a die that has actual dimension and then, through carefully applied pressure, forcing paper to assume the dimension of the die. Since there is no ink on the image, the result is purely textural. Foil stamping also uses a die, but instead of raising or indenting the surface of the paper, a foil is heatset into the paper. This foil can be a metallic, such as silver or gold, or it can be a flat pastel or other color.

Engraving and thermography will leave your image with a raised surface on the paper. This process is attractive because even type can possess a feeling of dimension—albeit slight.

Letterpress uses hot-metal die casts to transfer ink to the sheet. The result is very tactile because the casts leave an impression in the paper; letterpress is often used as a cheaper alternative to embossing.

TEXTURE MUST SUPPORT THE CONCEPT

We have discussed the central role that concept plays in design; that is, the idea is of primary concern, and anything that distracts from the idea is to be discouraged.

Since texture can be such a fun element to use,

Some designs use such a heavy texture that the type printed over it is virtually unreadable; even if this texture is appropriate to the concept, obscuring the type will still impede communication of the message.

it might on occasion be tempting to use a texture that is not sufficiently related to the concept of your design, or to use texture that is appropriate but that overwhelms the rest of the design. To avoid this scenario, keep in mind that texture should be used in a design to strengthen the idea—never simply to decorate.

There is an example of an annual report design by Steve Pattee on page 106 that I believe is a prime example of the appropriate use of texture. The booklet is for the Des Moines Metropolitan Area Solid Waste Agency and is simply entitled "This Annual Report Is Trash." The cover is printed on crudely recycled paper and creates a feeling that is very appropriate for the company.

On the other hand, some designs use such a heavy texture that the type that is printed over it is virtually unreadable; even if the texture was appropriate to the concept (and it's often not), by obscuring the type it still impedes communication of the piece's message.

If your idea doesn't immediately call for the use of a texture to reinforce your concept, it may be better to wait until other elements are in place and then see if the addition of a texture will enhance your design.

If texture still seems appropriate, consider the many textures that are at your fingertips and choose one that won't overwhelm your design. If you do choose to use a less subtle texture, design other elements accordingly—for instance, pick a bolder typeface that will be able to stand up to the texture you've picked. In general, however, textures that are playing a supporting role in designs will need to be subtle so they don't get in the way of other, more important, elements.

WHAT TO CONSIDER WHEN USING TEXTURE

1 Will an overall texture help to convey the idea of your design? Will texture be used to fill individual shapes or other portions of the design?

2 Have you considered the textures that surround you in everyday life? Will any of these textures strengthen your design?

3 Even if texture is not to be added graphically to your design, what role will be played by the texture of the paper you use?

4 Will you use artwork, in the form of a photograph or illustration, that conveys a feeling of texture?

5 Is silkscreen an option? Have you considered using embossing or debossing die? Will a foil stamp be appropriate to your idea? (Don't forget alternative printing methods.)

6 Do the textures you've chosen to use support or overwhelm the concept of your piece? Is the texture in your piece an integrated part of the concept or does it feel added on at the last minute?

EXERCISE

EXPLORING TEXTURE—
Using Texture as a Background

The contrasting textures of the thin, crisp line next to the fuzzy, more loosely defined stroke of a paintbrush give this design much of its effectiveness.

Choose three household items that can be used as background materials. Each of the items you choose should have a texture that distinctly contrasts with the other two. For example, you might choose a paper bag, a piece of burlap, a patterned piece of cloth, a panel of wood, a chunk of cement or a piece of tile. Now find another familiar object, such as a spoon, a piece of jewelry, or some other fairly small item. Place this item on each of the three background textures and notice how the backgrounds change the effect of the chosen object. You can see how compatible, for example, a piece of jewelry might be with a shiny tile of black Formica. But, interestingly, the same piece of jewelry has a completely different look when placed on a piece of cement—even though the object itself has not changed. The background texture is responsible for this change.

A common trend in photography is to purposely combine objects that are in vast contrast to each other. This contrast catches the eye of the viewer because the items displayed are so different. This concept also works for design when, as in the example to the right, a very crisp line is used in combination with the brushstroke of a paintbrush in a logo or other design.

There are no rules that say certain elements should never appear with another specific element, but this contrast may not always be appropriate for the idea you're trying to convey; as always, ask yourself whether the contrast adds or detracts from your message.

Structure

Now the fun begins. Once you understand the elements of design—line, type, shape and texture—you're prepared to use these raw materials within a structure. Remember: Good design structure is the result of a skillful combination of elements.

In building construction, the builder must understand when to use brick, and when lumber, steel or concrete would better suit his purposes. Using building materials as if they were interchangeable would result in disaster. A house may employ all four of these materials, but each for different intents—lumber for the frame of the house, brick for the exterior, concrete for the foundation, and steel rebar to reinforce the concrete.

In design, you'll have the building elements of line, type, shape and texture at your disposal; like the builder, with the various materials at his disposal, you'll discover that each element has different purposes, and that you can't use these elements interchangeably. Not every design should use all four of these elements. The careful building of your design will result in the most powerful communication to your audience.

Finding the appropriate use of line, type, shape and texture is the secret to creating an effective design, and the bylaws that govern good combinations of these elements are principles of structure. In this chapter we explore the four primary principles of structure—balance, contrast, unity, and value and color—to gain an understanding of each as it applies to building strong design.

In the end, the best results will be achieved through the use of these principles combined with *your* creativity.

Balance

Imagine yourself sitting at one end of a teeter-totter at your local park—you with the seat you occupy on the ground and the seat across from you empty and lifted off the ground. What kind of weight is required in the opposite seat to balance your weight evenly across the beam? The logical answer—and probably the first one that springs to mind—is that a person of equal size to you would properly balance your weight. However, that's not your only possibility—for instance, couldn't two persons, if each weighed half your weight, likewise balance you if they were to both sit at the other end of the teeter-totter? Of course.

THERE'S ALWAYS MORE THAN ONE WAY TO ACHIEVE BALANCE

Another possibility is that a smaller person could balance your weight if you were to slide toward the center of the beam until balance was achieved. In fact, if you center yourself between the two seats directly over the center beam, you can achieve balance without the help of another person. From there, let your imagination take over and you'll find any number of solutions, including removing the bar that carries the seats from the beam and relocating it to an off-center position, thereby creating a new center of balance.

A teeter-totter functions as intended when there are weights of relatively equal size on each side of the balance beam. In design, visual balance appeals to us because we rely on balance in nearly everything we do. The human body is balanced, enabling us to stand and move; so are the tires of a car. But balancing the elements of your design does not necessarily mean using symmetrical balance with an even number of elements that mirror each other—think of a tripod, for example, which achieves balance with an odd number of legs. In fact, while symmetry is useful for certain solutions, it

would become tiresome if every design required symmetrical balance to succeed.

BALANCE CAN CREATE A MOOD

In art, balance can create a powerful mood. Can you think of a classical painting that relies on symmetry to achieve a feeling? For instance, how about *American Gothic* by Grant Wood? This famous image of a farmer holding a pitchfork, standing with his wife by his side, communicates a calm—some would even say stagnant—feeling that is reinforced by the equal balance of the two figures centered in the format.

By contrast, *Starry Night* by Vincent Van Gogh has a very unstructured, freeform feel that's in part the result of the lack of strict balance. Balance or lack of balance can likewise affect your design, depending on the mood you want to create.

SYMMETRY

In the format at the top of the next page, we'll place a single horizontal line. If our goal is to achieve pure symmetry—that is, a design that's centered on all

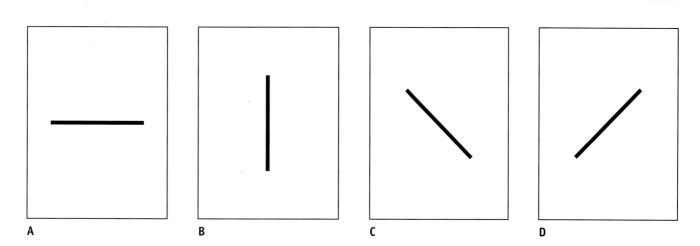

In examples A and B, the line is placed within the format to achieve pure symmetry—that is, a design that's absolutely centered on all sides. In examples C and D, the line is placed on a 45-degree angle, so it is not absolutely symmetrical in placement but achieves a somewhat different feeling of balance.

sides—we're somewhat limited in where we can place the line. True symmetry requires us to place the line centered left to right and top to bottom; with a vertical line, we would still center it left to right and top to bottom to achieve absolute symmetry.

Now let's put the same line on a 45-degree angle. When it's placed in the format centered left to right and top to bottom, it doesn't have the same feeling of complete symmetry, but the design is still balanced. Looking at the same angled line reversed, we achieve a slightly different feel, but maintain the same degree of symmetry and balance.

As an example of a piece that uses symmetry, look at the poster for the Southern Methodist University Friends of the Library on page 94, which uses strict symmetry to communicate the classical nature of this book-collecting contest. Note that the illustrations and typography all adhere to a strict symmetrical balance.

ASYMMETRY

Now, using the same line, place it in the format at any random position. Unless the line is placed perfectly horizontally or vertically, you'll automatically create an asymmetrical design—no matter where you place it. Is the design balanced?

Strictly speaking, the fact that the line is not centered pulls the design out of balance; at the same time, it creates a feel that the balanced design doesn't achieve. As mentioned earlier, the goal is not always to achieve an absolute balance. Sometimes the interest achieved by a lack of balance strengthens the impact of your design.

A line placed randomly within a format will create an asymmetrical design, but will achieve a feeling that a symmetrical design doesn't have.

Let's do another visual exercise. Suppose you create a format and introduce a shape into it. In my case, I've chosen to use a dot of roughly the same mass as the line in the illustration on the bottom of the previous page. Now try to place both the shape and the line in the format to create a perfectly symmetrical design.

If you place the dot above the line, is the design perfectly symmetrical? How about to either side of the line? You cannot create a perfectly symmetrical design with these two shapes; even if you balance the design side to side, you won't be able to center it from top to bottom. The only way to create a design that's perfectly symmetrical is to introduce another line or dot, which will allow you to center the design completely. When you introduce a second dot into the format, you can achieve perfect symmetry.

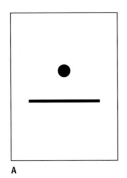 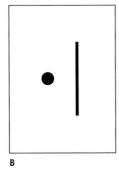

A B C

Perfect symmetry can't be achieved with just a single dot and a single line (examples A and B). You may need to add (or remove) elements to your design if you want to achieve perfect symmetry (example C).

ASYMMETRICAL BALANCE

Now place a third dot into the format. Once again, it's impossible to have complete symmetry, because the third dot will not allow you to center the design both vertically and horizontally. It does, however, allow me to demonstrate the next level of balance.

Going back to our teeter-totter example, I mentioned the possibility of balancing your weight with two persons of exactly half your weight. While this arrangement would not be symmetrical, it would nevertheless be balanced.

The illustration below shows that it's possible to place the three dots and the line in the format in a number of configurations and still distribute the mass in the format equally. Balance does not necessarily require perfect symmetry. In fact, while designs that use absolute symmetry can be very appealing when used for the right purpose, your possibilities are widened when you use balance to create interest without regard to perfect symmetry. This is called *asymmetrical balance*.

A B C

These illustrations show examples of asymmetrical balance. With three dots and a line you cannot achieve perfect symmetry, but you can achieve asymmetrical balance by evenly distributing the total mass within the format.

TENSION

To create an entirely different feeling, let's try using the same elements while intentionally ignoring balance. What moods are created in the extreme examples below? All of these designs tend to activate the format space in a different way. Some of the designs create what might be termed *tension*.

At certain times, tension is useful to communicate the feeling of the design; sometimes tension is added to create interest by throwing a design out of balance. There are no rules to follow except the visual needs of your concept.

For example, if you are designing an editorial spread for a magazine with the turbulent 1960s as subject matter, tension might be entirely appropriate. The concept of the design, or the text used in it, will give you an idea about whether an unbalanced feeling is appropriate for your piece.

BALANCE USING "REAL" DESIGN ELEMENTS

In the previous exercises I used lines and dots—elements in greatly simplified form—to get my basic ideas across. The possibilities for communication expand greatly as you use photographs, illustrations, blocks of actual text and other substantial elements in your design.

But don't rely on the content of a photograph or the words in the text alone to communicate your message. Instead, focus on the basic design of the format and how the position of each piece of art, each block of text and every bit of texture can enhance the concept. Always keep in mind that you can create feelings and moods with even the simplest of elements. As the elements you use become more substantial, your possibilities will become infinite.

As you learn to use balance to create mood, you enhance your design skills and enable more effective communication of your concept.

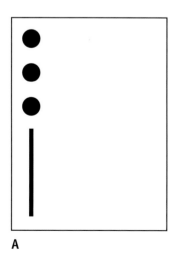
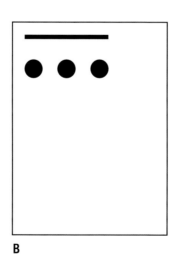
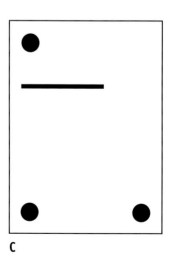

A B C

Sometimes an effective design will be purposely unbalanced. These three examples show designs that tend to activate the format in ways that a balanced design never could. You might say that some unbalanced designs create a feeling of tension.

WHAT TO CONSIDER WHEN STRIVING FOR BALANCE

1 Which type of balance will be more appropriate for your concept? Does the idea call for symmetrical balance or asymmetrical balance?

2 Does your design need a purposely unbalanced look (tension)? If so, have you pushed your design to feel obviously unbalanced?

3 What elements will you use to achieve balance? Will you balance elements that are similar to one another or elements that are different?

4 What are the different moods you can create with the balance of your design? Have you used balance to its potential in your design? Is it contributing to your concept?

5 Have you let your art and concept dictate the needs of your design in terms of balance? (Be careful not to let your desire to achieve a certain balanced or unbalanced look overwhelm the needs of the design.)

EXERCISE

EXPLORING BALANCE—Symmetry & Asymmetry

The experienced designer can use both symmetry and asymmetry to create exciting effects. To explore the possibilities of combining symmetry and asymmetry, try dividing your format in half vertically, making the left half white and the right half black. At this point the format is symmetrically divided.

Introduce a number of black elements into the white half—in this case, I've chosen three lines and three dots. Likewise, place three white lines and dots in the black half of the design.

By placing the lines and dots in the same position on both sides of the format, you create an orderly feel. Next, try placing the dots and lines in random positions on both sides of the format. Then try placing the dots and lines in an orderly fashion on one side of the format and in a random arrangement on the other side. As you see, each configuration creates a different feeling.

Using simplified elements in this exercise helps you ignore the content that these dots would contain if they were full-size illustrations or photos in an actual design. Notice how the position of these simple elements helps to communicate the concept.

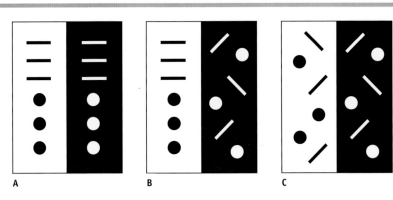

A B C

The experienced designer can use symmetry, asymmetry or a combination of the two. In example A, elements are placed in an orderly way on both sides of the design; in B, elements are orderly on one side of the format and randomly placed on the other side; and in C, elements are placed at random on both sides. Notice how each configuration creates a different feeling.

Contrast

How boring speech would be and how difficult it would be to communicate emotions verbally without the use of inflection—the contrasts of pitch and noise levels. The crash of a cymbal in orchestral music that's otherwise subtle and quiet adds excitement and increases your listening enjoyment. Or consider the moon—without the benefit of a dark sky, it would be difficult, if not impossible, to see. In each of these cases, contrast is at work to enhance the effect of an experience.

Contrast is an especially important principle in graphic design, and a crucial tool to communicate an idea. It is also one of the most effortless principles to put into action.

CONTRAST IS AUTOMATIC

As soon as you add any element to a blank page, you've used contrast. Consequently, it may be one of the most undervalued principles of design, because its use is to some extent automatic.

Let's begin by using the example that we started with in the previous exercise on balance on page 54. Contrast was used to divide the format into two parts, one white and the other black. Even before you placed the lines and dots into each of the divided sections, you had the benefit of contrast at work for you—black against white. We then placed lines and dots on each half of the format to demonstrate balance.

What would happen if the size of these objects contrasted sharply—if, for instance, one of the dots was twice as big as the others? By contrasting the size of the elements, the design moves into another dimension and the designer has another tool at his disposal. If you were trying to achieve balance, it would be necessary to adjust the design to accommodate this larger object. Now let's make that same dot a great deal larger than the others. Because of the principle of contrast, further adjustment is necessary to maintain visual balance.

In this exercise, white and black dots provide the maximum of contrast. Suppose you were to substitute a gray dot for the large white dot. What impact does this adjustment have on the design? Or try substituting a square for one of the dots. The options are endless.

A

B

C

Simply dividing the format into black and white halves as in example A adds immediate contrast. When one of the elements is noticeably larger than the others, in B, another level of contrast is attained. In C, balance must then be adjusted to accommodate the larger element.

This simple example uses very plain shapes. When subject matter is injected into these shapes, the dynamics of contrast become even more powerful.

CONTRAST CAN STRENGTHEN AN IDEA

How can contrast help you strengthen an idea? In certain cases, the use of contrast seems very natural, and hardly requires a conscious decision. Say you were asked to design a poster showing the moon in all its phases. Wouldn't it seem natural to use a dark background behind the moons to allow them to stand out in the format? On the other hand, suppose you were asked to design a poster illustrating for skiers the different runs offered at a resort. Placing the ski runs on a white background would seem equally appropriate.

These two examples offer simplified solutions, but most problems you'll face as a graphic designer will not be so obvious.

For example, I was asked to design a recruitment mailer for Bucknell University (shown on page 125)

In some cases, the use of contrast is so natural that it's almost automatic. An illustration showing phases of the moon just naturally calls for a dark background to suggest the night sky; an illustration of a ski run seems to belong on a white background, suggesting snow.

that featured the idea that students are typically offered two choices when deciding which college to attend. The concept was to contrast a small college setting, with its smaller class sizes and more social environment, to a university atmosphere, which usually provides a broader curriculum and a greater range of student diversity. Bucknell University wanted to show potential students that they could offer the best of both college experiences.

I set up the idea by proposing that the decision of where to attend school might require a student to choose one atmosphere over the other, college or university, A or B. Thus, the theme of the piece itself provided the initial contrast.

I then divided the format into two halves, one side black and the other metallic blue, to visually communicate that the student has a choice. This contrast of color added visual impact to the design, and the idea was further reinforced by setting up the decision as a multiple choice question, which also ties into the education theme.

But the main point is that the visual contrast, along with the contrast between choices provided in the text, served to strengthen the main idea of the piece. That is, this design was tied directly to the idea that was communicated, and the principle of contrast served to strengthen the idea.

CONTRAST CAN BE ACHIEVED IN A VARIETY OF WAYS

While design elements are most often used to support the content of the message, a powerful con-

trast can be provided with the use of contradiction. In the example below, the word *big*, when set in type that fills the format, lives up to its definition. When set in tiny type, *small* does the same. But what if you were to set the word *big* in very small type and the word *small* in type that fills the format? This use of contradiction implies a completely different concept.

There's a classic poster by designer Jack Summerford that simply uses the word *Helvetica* spelled out across the poster in Garamond type. The contradiction of the presentation and content of the word is what makes the idea work. It needs no other embellishment.

When using contrast to express an idea, entertain all the possibilities: Contrast may be provided in size, color, shape, texture, typeface and more. Think in terms of large or small, black or white, straight or crooked, perpendicular or angular, thick or thin, smooth or rough, shiny or dull, serif or sans serif,

angular or rounded, organized or haphazard, centered or off-center.

But carefully choose the combination that best represents the mood or idea you wish to communicate. Contrast that doesn't have the idea in mind can cloud the concept.

CONTRAST IN VALUE, COLOR, SHAPE AND TEXTURE

Contrast in value and color are indispensable in your design work. We'll discuss value and color in greater detail at the end of this chapter, but common sense will tell you that a piece without value contrast (such as a gray-on-gray piece) or without color contrast (such as a light-yellow-on-cream piece) may not have the impact that more high-contrast pieces—such as a black-on-white or a bright-yellow-on-purple piece—would have.

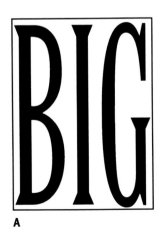

A

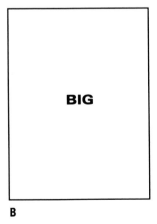

B

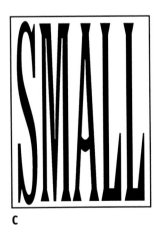

C

D

While typefaces are most often used to support the content of the message, a powerful contrast can be provided when the typeface (or size of type) contradicts the content of the text.

Contrast in shape can be used to portray whimsy or to create a somber tone. Who can deny the power of the German swastika when it comes to creating an identity? The hard-edged, spiderlike design was the perfect symbol to communicate the intensity of Hitler's vision of the world. In contrast, who can see a 1960s poster of the flower generation and not get an instant feeling from its soft, flowing lines for the carefree attitudes that prevailed in that era?

Similarly, architecture constantly uses contrast in textures to create moods. The contrast of two very different materials, such as shiny chrome against a concrete wall, is intriguing. When you look around your neighborhood, how many combinations of contrasting building materials can you spot? Something as simple as shiny white wood paneling against a brick wall is an example of contrast at work.

CONTRAST IN TYPOGRAPHY

Typography affords the designer a great opportunity to use contrast.

If you look at any book or magazine layout, you'll see contrast in typography at work—larger headlines contrast with smaller subheads, photo captions and body copy. Contrast in type size can be used to lead the viewer's eye, which is why the headline is typically larger than the body copy, and captions are relatively small compared to both.

If you look at a printed page where the writer is limited to one size of type, the writer will often use boldface, underline the letters, or use all uppercase letters for a headline to make it more prominent. The difference between the normal type and the boldface, underlined or uppercase type is simply contrast.

Type is a crucial element

Type is a crucial element for any design in which it appears, and it is used in so many designs. Type is perceived by the viewer in several ways simultaneously – as text to read, as shape, and as a purely visual element, in which the letterforms themselves convey a feeling or a meaning. Consequently, learning to use type well is one of the most important skills you can develop as a graphic designer.

When type is used badly, however, it can be so inappropriate to the communication that it interferes with the intended message.

Using type well means using it appropriately to communicate, taking into consideration the various ways it will be perceived by the viewer. When you've used the character of a visual symbol – the typeface itself – to visually convey the meaning of the written word that the symbol represents, you've effectively used type to solve a problem. When type is used well, it may even stand alone, without an accompanying illustration or a photograph.

Type is a crucial element

Type is a crucial element for any design in which it appears, and it is used in so many designs. Type is perceived by the viewer in several ways simultaneously – as text to read, as shape, and as a purely visual element, in which the letterforms themselves convey a feeling or a meaning. Consequently, learning to use type well is one of the most important skills you can develop as a graphic designer.

When type is used badly, however, it can be so inappropriate to the communication that it interferes with the intended message.

Using type well means using it appropriately to communicate, taking into consideration the various ways it will be perceived by the viewer. When you've used the character of a visual symbol – the typeface itself – to visually convey the meaning of the written word that the symbol represents, you've effectively used type to solve a problem. When type is used well, it may even stand alone, without an accompanying illustration or a photograph.

Use of contrasting (yet complementary) typefaces in the same design can provide a lot of interest. In many cases, the use of a single face for everything is not nearly as attractive.

The designer works in the same way except at a more powerful level, but this power is often underutilized. If your headline is not made prominent enough, you risk confusing the reader and reducing the headline's impact. Contrasting typefaces also allow you to add interest to your design. In the bottom left example on the previous page, there are four typefaces, consisting of serif, sans serif and display faces, that work well together in different text blocks, such as headlines, body text, pull quotes and sidebars. The example to the right consists of the same layout using one face for all text blocks. Notice how much more interesting the first example is. This is due to contrast.

There is no rule telling you how many different faces you can use in a single layout. I have seen very successful designs that have employed a dozen faces, but using multiple faces successfully is usually the work of an experienced designer. Until you get a feel for what is and is not appropriate, it may be advisable to try to stick with two or three.

When placing type within a format, ask yourself what you can do with that type to strengthen your idea—consider contrasting the type size, type style or weight of the type (using book, medium or bold). You may try varying leading (space between the lines of type) or density (space between the individual characters, or kerning). You may also try different type positions or column widths. Making the body copy large for the sake of readability is fine, but at a certain size, known only by experimentation, text that is too large can appear awkward and clunky.

Similarly, contrast comes into play with the density of the type. In the example at right, the same layout is done using different densities of type. In each

Ballet

Ballet is a dance in which conventional poses and steps are combined with light flowing figures such as leaps and turns. A ballet is a theatrical art form using ballet dancing, music, and scenery to convey a story, theme, or atmosphere.

Ballet

Ballet is a dance in which conventional poses and steps are combined with light flowing figures such as leaps and turns. A ballet is a theatrical art form using ballet dancing, music, and scenery to convey a story, theme, or atmosphere.

In addition to contrasting typefaces, type sizes and width of text columns, you can also vary the density of type used. Here, the same type layout is done using two different densities of type. Which is more appropriate to the idea?

example the feeling is different. Which is more appropriate to the idea?

A very long, very narrow column of text may annoy the reader by causing the eye to travel back and forth too often to descend the column. Likewise, a column that is too wide can cause the reader's eye to tire, and may make it difficult for her to keep her place in

the text. I can't tell you what's too narrow or too wide; the goal is to be sensitive to the reader and the written message. Remember: In most cases, the conceptual design that works *with* the written message has a better chance of communicating with full power.

A final caution about contrast: All contrasts do not have to be dramatic. When suitable to the overall message of your piece, diminished contrast—or a more subtle contrast—may in fact be desirable. When going for this effect, make sure that the difference, while subtle, is still discernible; otherwise, it may go unnoticed or, even worse, may look like a mistake.

In summary, contrast enhances our enjoyment of differences around us in everyday life. Design is merely an extension of everyday life that allows us to communicate visual concepts and ideas to each other. Contrast is a powerful design principle available to distinguish your message.

WHAT TO CONSIDER WHEN STRIVING FOR CONTRAST

1 Do the contrasts you've chosen to use for your design strengthen its idea?

2 Have you fully considered all the ways you might achieve contrast? Do you want to use contrast in value or color? Shape? Texture? Typography?

3 Are your choices of contrast in typography suitable to the message of the design? Does your use of type make the piece more or less readable for your audience? More or less visually appealing to your audience?

4 Have you pushed contrast to its most potent level? That is, if you're using large and small photographs, is there enough difference between the two sizes to show an obvious contrast?

5 Have you considered the idea of diminished contrast? (Not every successful design uses contrast as polar opposites. Sometimes subtlety can add strength to a design—subtle color shifts, subtle differences in type, etc.)

EXERCISE

EXPLORING CONTRAST—Portraying Ideas Through Contrast

This exercise will help you explore the power of contrast in design. Cut one 6" square out of a colored piece of paper and six 1" circles out of paper of a contrasting color. Create designs on an 8½" x 11" piece of white paper to convey the following concepts:

1. Captivity

2. Freedom

3. Love

Since the small circular pieces of paper are in automatic contrast to the single large square (in size as well as color), you will be compelled to find solutions where the principle of contrast guides the design.

For instance, one way to convey "captivity" would be to place the six circular shapes within the square. What other, less obvious ways are there to illustrate the concept of captivity? How about showing the six circles being crowded into a corner of the format by the square, as in the example to the right?

What happens if you divide the format in half horizontally—the top being white and the bottom black? How does this new contrasting format expand your ability to convey the three themes? Do the shapes take on new meaning as they sit on either the white or the black side?

Now try to illustrate the other two concepts listed above. Are there other concepts you can think of that you could illustrate using these same materials?

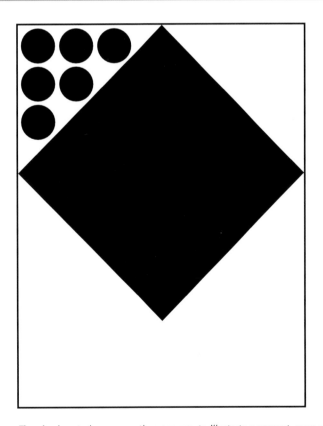

There's almost always more than one way to illustrate a concept, even using the same elements. To convey the idea of "captivity," you might think first of putting the smaller circles into the larger square. But what about showing the circles being crowded into a corner by the square?

Unity

You've heard the expression, "The whole is greater than the sum of its parts." In a single design, it's possible to use each available element—line, type, shape and texture—independently, but true power lies in the skillful coordination of these elements.

In fact, multiple elements in a design will necessarily work either with each other, providing a unified whole, or against each other, leaving the design with a disjointed feeling. Even if individual elements are suitable independently, they may not be suitable together. Unity—the coordination of design elements so that each works well with the others—plays a fundamental role in any design.

ACHIEVING UNITY WITH A GRID

As you look at your house, you may not be aware that there is a framework of cement and wood that is supporting walls, floors and ceilings and providing an underlying structure. Similarly, as you look at a successful design, you may not be aware of its underlying structure, but it is as important to the success of the design as the framework is to your house. In design, this structure is usually called a *grid*.

Books, magazines, brochures, newsletters and other multipage documents are rarely built without the help of a grid. A grid can provide unity in a variety of ways: through the use of a consistent border, a set column width for type, the same space between columns, a consistent size of text type, a common position for folios (page numbers), and a common opening layout for different sections.

When a grid is functioning successfully, the reader gets the feeling that the design is working together from page to page. The importance of this underlying structure in creating unity in a design can be discovered using the following example.

A SIMPLE GRID

At the top row on the right, using three circles and three squares, I've created a different design on four different formats without the use of an underlying grid. (By virtue of my use of common shapes, I have achieved some degree of unity in the layouts, even without the use of a grid.)

Now let's take the same format and apply a checkerboard-style grid that divides the space into three horizontal and three vertical sections of equal size. Let's place the circles and squares in the four new formats, lining up the edges of each object with one of the given grid lines.

Now make the grid invisible and compare the two sets of four layouts. Notice that the layouts in the second group appear more consistent with one another—a result of the underlying structure.

WHEN TO BREAK OUT OF THE MOLD

You might also notice that the second group of formats doesn't have quite the spontaneity or visual

A

B

C

A simple grid can provide consistency between pages of a design. In example A, elements are placed into four different formats at random; no underlying grid is used. In B, these same elements are arranged in a more orderly way with the help of a visible grid. Finally, in C, this grid is made invisible, and the elements are left in place. Notice how the layouts in C are more consistent with one another than those in A.

intrigue that the first group has. This is also a result of the grid we've established. Grids, when followed tightly, function to unify the basic design—sometimes at the expense of the designer's freedom of expression.

Once this basic structure is in place, the creative designer can strategically break out of the grid to give the design vitality. But this must be done with some thought, or it can be overdone, weakening the grid's usefulness.

Grids may be very simple, with only a few set areas specified, or very complicated, with a predetermined placement for almost every element. But whether simple or complex, you must decide how strictly to adhere to grid lines; this adherence can range

from very strict to very loose.

If you're a beginning designer, you may want to start by using a fairly tight grid, or one that strictly guides a placement for most of the elements on the page. This will help you achieve a feeling of unity—thus ensuring a more professional look for your piece. After you gain experience using a tight grid, you can begin to experiment with elements that purposely violate the grid. As mentioned earlier, this is where you will achieve the most vitality in your design.

WHEN DO YOU NEED A GRID?

Unity can be achieved without the use of a grid. A poster, for example, or a single-page document would not benefit as much from a grid as a multipage piece. Even so, it's possible to establish a grid for your poster if you want to, and may in fact be useful if you're juggling a lot of different elements.

The example below shows a poster where the

PHAMBO'S LOGOS

This poster was designed to display a variety of different logos. By virtue of the simple underlying grid, the design feels organized, even though it's composed of a lot of little elements that are otherwise unrelated.

intent was to display a variety of logos. By virtue of the simple underlying grid, the poster feels organized. Would it be possible to do the same poster without an underlying structure? Yes. A random placement of logos, perhaps even tilting the logos at different angles, would achieve an entirely different feel. But this randomness might detract from the point of this particular poster, which is to feature the logos themselves as the main attraction.

UNIFY YOUR DESIGN USING SIMILAR ELEMENTS

How can you unify your design without the use of a grid? One way is by using design elements that are already similar. In the example below, the design uses line and type. Each element of line is different by virtue of weight and color. The elements of type are also different styles and sizes. It would be possible to make all

the lines the same weight, length and color, and all the characters of type the same size and face. By doing this, you've automatically unified the design without repositioning the elements themselves. But, if taken to this extreme, you've almost certainly created a design with less visual appeal, since you've practically eliminated the equally important principle of contrast.

Instead of making all the lines identical in every respect, try unifying just one aspect of each line, perhaps the weight. Instead of using type of the same style, size and weight, try unifying just the type style. You will have achieved a good deal of unity without taking away the individual identity of each element.

LEADING THE EYE THROUGH DIFFERENT ELEMENTS

Just as an architect uses a careful placement of doors and walls to lead the flow of traffic through a

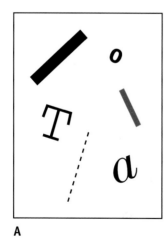

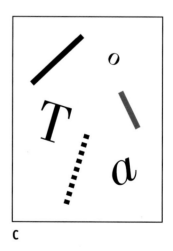

A **B** **C**

Using similar elements is one way to unify a design. In example A, each line is different from the others by virtue of weight and color, and the elements of type are also different (varying in size and style). In B, all of the elements have been unified by making lines, type and other elements all the same in every possible way. In C, a happy medium has been reached, with lines that are all the same weight but different lengths, and with type that's all the same style, but of different sizes and weights.

A **B** **C**

The placement of elements is one factor that determines the order in which the eye perceives them. In example A, the elements are placed at random in the format. By virtue of its size, the shape draws the eye first. In B, placing the headline type within the shape causes the eye to go first to the headline, then to the shape, and finally to the rest of the type. In C, the eye goes to the shape last, simply because of the way it's placed in relation to the other elements.

space in an optimal fashion, so does a designer use careful placement of design elements to lead the viewer's eye through a piece. A design that fails to do this runs the risk of disrupting the communication of the concept.

The tools that will help you effectively lead the eye include the position of the elements and their relative size, subject matter, and value or color.

To demonstrate this, let's consider an example in which some of these factors interact to cause the viewer to see elements first in one order and then in another. The illustration above uses three elements: a shape, headline type and text. In the first configuration, the elements are placed randomly on the format. The shape, by virtue of its size, commands the most attention—so this is where the eye enters the design. But this might not be what you want if, for instance, you're designing a poster and need to have the reader notice the headline first. Is it possible, using these same ele-

ments on the format, to persuade the reader to read the large type first?

The second configuration demonstrates that, when you place the headline type within the shape, the shape tends to act as a frame on a painting, taking second place behind the type and guiding the eye to the type instead of the shape.

What happens when you place the text type inside the shape as in the third example? The shape now becomes the last element to command attention. We have successfully led the eye of the viewer.

LEADING THE EYE THROUGH SIMILAR ELEMENTS

An important part of effective layout is knowing how to lead the eye through your design even when the design consists of similar elements. Suppose, for example, you have four photographs that are different

in content but that have roughly the same mass.

In the three formats below, these photographs are represented by a square, a circle, a diamond and a triangle. These shapes are placed in different positions to demonstrate how you can lead the eye. When you add subject matter to the photographs, you increase the ability to control the eye. But for now, let's just examine how these various placements will lead to different "readings" of the same elements.

In the first example, by isolating one of the shapes and grouping the other three together, you automatically cause the eye to begin with the isolated shape. In this way, you lead the eye to discover the contents of the isolated photograph first.

In the second example, three of the four shapes (or photographs) fall within a grid, and the fourth falls outside the grid. This is similar to the treatment in the first example, in which one of the shapes is set apart from the other three. This, likewise, causes the eye to

single out the element that's set apart—the one outside the grid.

In the third example, the four photographs are placed in a line. Because we are conditioned to read left to right, the eye will almost always begin at far left and proceed to the right with visual elements as well as with words.

These examples are simplified, of course, but still help to demonstrate basic ways you may begin to lead the eye of the viewer, which is always required in constructing an effective design.

This same concept also works with the elements of type, line and texture. In fact, if you have this much control over the attention of the reader with the use of similar elements, imagine what you can do as you introduce elements of different size, color, position and subject matter into the design. In the hands of a skilled designer, the principle of unity is a significant asset. If this principle is ignored, a lack of unity and "eye

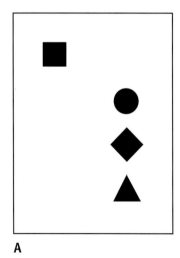

A

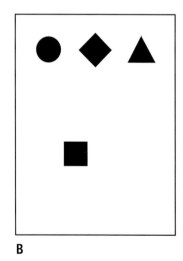

B

C

The eye can be led in a particular order even with the use of similar elements. In example A, one of the shapes is isolated from the other three, causing the eye to go there first. In B, three of the four shapes fall within a grid, and the fourth falls outside of it. Where does your eye go first in this case? In C, the shapes are arranged in a line, causing the eye to "read" them left to right.

control" can confuse the reader and muddy the concept of your design.

UNITY VERSUS CONTRAST

Earlier, we discussed the importance of contrast. Often, the more "the same" something is—for example, the tone pitch of a voice—the more monotony you experience. So unity is important, but not at the expense of contrast, which provides interest.

Achieving an appropriate balance between unity and contrast is a tricky and sensitive issue. On one end of the scale you have pure contrast, which might be defined as chaos, and on the other hand, complete unity, which might be defined as sameness to the point of boredom. As you gain experience with design, you will find that magical balance that allows your design to maintain interest without feeling unconnected or fractured.

WHAT TO CONSIDER WHEN STRIVING FOR UNITY

1 Does the design you want to do call for a grid? (For most multipage documents, a grid is probably necessary; single-page documents may or may not benefit from a grid.)

2 How complex will your grid need to be? What elements will be consistently placed according to the grid lines?

3 Where might it benefit your design to break the grid? When you look at pages where you've broken your grid, do they still seem connected to the pages where your grid is intact? (If not, consider whether you've been too free in breaking your grid.)

4 Have you been able to achieve unity through the use of similar elements? Do your lines, blocks of text copy and other elements on the page look as if they belong together in some way?

5 Does your design lead the eye? Is there an obvious place in your design where the eye enters and then travels through the elements?

6 Have you eliminated any elements that distract the eye and pull it away from important parts of your design?

EXERCISE

EXPLORING UNITY—Using a Grid

Strongly related to the concept of unity is the idea of a grid system. The word *grid* means a structure upon which elements can be placed in an orderly way. A grid may be considered to lie behind the design—and is

Here are three sample design "pages" that can be created using the grid you just made and nine color squares (six 1" squares, two 2" squares and one 4" square). Because of the underlying grid, and because the elements are similar, any pattern you create in this way will have a certain cohesiveness with any other pattern made the same way.

usually invisible in the finished design. Most publications are laid out with a grid system; if this grid is noticeable, it becomes a design element. With the use of a simple grid, you can build a design that feels cohesive.

On a white piece of 8½" x 11" paper, draw a vertical line 1¼" from the left margin and another six verti-cal lines 1" apart, starting from the first vertical line you drew. Following the same procedure, draw a horizon-tal line 1½" from the top margin and eight more horizontal lines 1" apart, starting from the top horizontal line and working downward (as shown to the far right.

Next, cut six 1" squares out of black or colored paper. Then cut two 2" squares and one 4" square out of the same paper. Using all of these squares, arrange them on the grid in as many configurations as you can dream up. Be imaginative!

Because of the underlying grid, and because you're using elements that are similar (all the shapes are square, although they are different in size), you'll notice a certain cohesive-ness as you place these patterns side by side. These patterns might be con-sidered to be simplified pages of a multipage document, since they share an appropriate unity in their design.

Three examples are shown above.

Create this grid in the following way: On a white piece of 8½" x 11" paper, draw a ver-tical line 1¼" from the left margin and another six vertical lines, each 1" apart. Next, draw a horizontal line 1½" from the top margin and eight more horizontal lines, each 1" apart.

Value

Earlier we covered the different elements—line, type, shape and texture—that you can use in a design, and then we discussed some of the design principles—balance, contrast and unity—that help you organize these raw materials. To add dimension and depth to your designs, you also need to understand the principles of color and value. Since value is intrinsic in all design but color is not, we'll discuss value first.

VALUE IS INHERENT IN ANY DESIGN

A successful design generally needs to work well in black and white: Color shouldn't be used as a crutch to prop up an otherwise poor design. Value, like contrast, is inherent in any design as soon as any kind of image is placed in the format. You might think of it as an automatic ingredient.

What is value? It can be simply defined as the relative lightness or darkness of an object. Let's examine how value works in everyday life and then apply those same principles to value in design.

VALUE WORKS IN NATURE

There are many examples of value at work in our everyday life. For instance, you will find value present in nature to great effect. Imagine yourself in the thick of a dark forest; everything around you is in the shade of the trees, but looking ahead you spot a clear meadow shining in the sun. Your eye is immediately drawn to this clearing because of the striking difference between shade and sunlight.

Additionally, many animals and insects utilize value as a defense mechanism: By assuming colors in shades that are similar to their environment, they pro-

tect themselves against their natural predators. (Most camouflage relies on color, as well as value, but even the proper color wouldn't hide the animal unless the value was right, too.)

VALUE CAN BE A POWERFUL INFLUENCE

Man is also adept at using value when it serves a specific purpose. Think of the way a white wedding dress—particularly next to the dark suits of the groom and ushers—gives emphasis to the bride. And it was no arbitrary decision during World War II to paint Navy battleships gray; this color was discovered to be the most effective at concealing ships from enemy aircraft.

Despite these examples from nature and the fields of human endeavor, designers often fail to recognize that the skillful manipulation of value can actually make their design elements come alive.

As a final example of the great importance of value, imagine you are in charge of putting on a fireworks display. You purchase the best fireworks you can find and assemble a large crowd to watch them explode. The only problem is you select the middle of the afternoon to stage the event. As each rocket explodes in the sky you hear the boom and see the smoke, but the major effect is gone. The night sky

provides a background of the right value to contrast with the fireworks.

Effective use of value in a design is like the addition of the black sky in a fireworks show; it allows the viewer to see the design elements at their full potential.

ALL ELEMENTS HAVE VALUE

Any element added to a format automatically brings value with it, since every element you deal with contains a degree of value, anywhere from 1 percent to 100 percent black. Of course, that assumes a white or gray background. If your background is completely black, any elements you add will be between 1 percent and 100 percent white. This fact implies another quality of value: Value is relative.

VALUE IS RELATIVE

Every element that can be seen with the naked eye, such as a light-gray box on a white background, is already using the principle of value. The value of something (the gray box) is relative to the other elements near it and to the background it's placed on (the white background).

The greater the difference in value between the object and its background, the greater the contrast. So value is related to contrast, but it isn't the same thing. You can achieve contrast without value (for example, by using varying shapes or textures), but you can't have value without contrast. The contrast may be great (black on white) or small (similar shades of gray), but it will be there.

Since value is such a powerful influence on the feel and mood of a design (whether it's done intentionally or unintentionally), your goal should be to learn how to use value intentionally to create the strongest possible design.

The skillful use of value in your designs will add power and appropriateness. The example below shows the impact of a single element placed into the format in three varying shades. None of the three can be called

A B C

*Notice the different impressions created by a single element that's placed in the format in three varying shades,
or values. The "correct" value is the one that gives the desired effect for a particular design.*

the *correct* value, since what matters most is the desired effect.

But it is correct to say that values can be used to establish contrast, or the opposite—a subtle blending of shades. What differences in mood are created when the values create a strong contrast? The more stark the element is against the background, the bolder the statement. On the other hand, a softness is created—in either high key (light tones) or low key (dark tones)—by using subtlety in value and minimal contrast.

VALUE CREATES MOVEMENT AND DIRECTION

When a black dot is placed on a stark white format, as in example A below left, the contrast in value is great and the dot is very prominent. When this element shares space with another like element in example B, it also shares equal importance. But make one of the elements darker than the other as in example C, and you begin to create movement and direction.

When the format is flooded with elements of equal value, as in example A in the illustration at bottom right, they will share equal prominence. This can create a feeling of sameness. When the elements in the format are of different value (example B), you begin to create movement through value. For example, when you place the dots in a specific order, their value leads the eye in a certain direction, just as you can lead the eye using shapes and other elements by placing them in a pattern. Notice how the design is given movement and direction when the dots are placed in a pattern according to value (example C). The eye tends to go first to the shapes that have the most contrast.

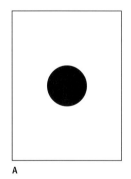 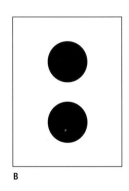 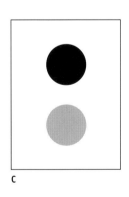

A B C

(Left) A black dot placed on a white format creates a sharp contrast (example A), but the design is static. When a second dot of equal value is added, as in B, the two elements share equal importance, but the format remains static. When a second dot of a different value is added, however, you begin to see movement and direction created through the use of value (example C).

(Right) When a format is flooded with elements of equal value, a static feeling of sameness can be created (A). But introduce just a few elements of differing values, and you begin to create movement (B). When these elements are placed in a specific order (as in C), you can actually lead the eye using value, just as you lead the eye using shape and other elements.

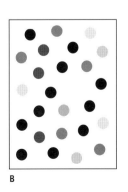 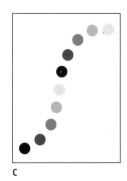

A B C

VALUE CAN CREATE A MOOD

No other principle of structure has more power to create a mood than value. With the effective use of black, white and gray values you can add power or change the mood of a design. Consider the classic design of the Beatles' "White Album." The cover consists of a sea of white with the small word "Beatles" embossed on the front; the only value is the slightest hint of shading where the embossed letters cast their shadow on the pure white background. In a time when many album covers were being designed to excess with the 1960s genre of psychedelic art, this simple cover, with its very restrained use of value, was full of impact.

WHAT TO CONSIDER
WHEN USING VALUE

1 Have you really chosen the values present in your design? Or have you allowed values to present themselves as they will, without careful use and manipulation where necessary?

2 Have you intentionally chosen values that provide contrast? Is this contrast appropriate to the idea of your design?

3 Have you intentionally chosen values that are very similar to provide a subtle, or blended, effect? Is this effect appropriate to the idea of your design?

4 Does value help move the eye through your design? (Keep in mind that the eye tends first to go to shapes that have the most contrast.)

5 What mood is created by the values you've chosen?

Color

Once you're comfortable with value, you can begin to appreciate the added dimension of color. You have considerably more power to create a mood when you can not only decide on the intensity of the shade of an element, but can also determine the color. These decisions require great care to ensure the success of the design.

COLOR CAN OVERRIDE VALUE

Below is a continuation of the example in the section on value (page 71). Introduce into this same format a single red dot.

Suddenly this dot is the center of attention. If this design were to be converted into a black-and-white design, the red dot would become gray and blend into the design. But by virtue of its color, the red dot becomes the focus. This simple example illustrates an important concept: Color has the power to override value and change the intent of a design. For this reason, color must be used carefully so as not to lead your design astray from its original intent.

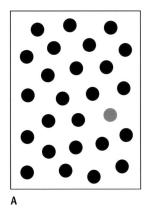

A

As a demonstration of how color can override value, consider this format—it's identical in every way (but one) to example A on page 71, which means the entire format is filled with dots of equal value. But one of the dots is red, so your attention immediately goes there first. Notice how the value of this red dot hasn't changed—it's only the change in color that draws your attention.

INTRINSIC PROPERTIES OF COLOR

Using color as a design tool is largely a matter of taste. We make color decisions every day about our wardrobe—being careful (or not, depending on our intent) to wear appropriate color combinations. While there are no hard-and-fast rules that dictate which colors go together, there are certain unchanging properties of individual colors. Knowing these properties can help you decide when to follow the rules, when to bend or break them, and when to ignore them completely and come up with new ones.

WARM AND COOL COLORS

The color wheel below shows colors arranged in the order of the spectrum; that is, red, orange, yellow,

The color wheel is a great tool for understanding color theory. In it, the colors of the spectrum are all arranged in order, from the warmest color (red) to the coolest color (blue).

green, blue and purple. If you start with red, the warmest color, the remaining colors in the wheel follow in order, and become increasingly cooler until you reach blue, the coolest color. All colors can be classified as either *warm* or *cool*. Warm tones lean to the red, orange and yellow side of the color spectrum; cool colors lean to the green, blue and purple side.

One quick way to understand warm and cool colors is to begin with a flat gray; that is, a gray that has no color pigment, but is just a shading of pure black. Using a common no. 1 pencil, create two blocks of shading that are medium gray. Then, using a red pencil, shade very lightly over one block of gray. Using a blue pencil, shade over the second block of gray. Note how this minor modification of the gray boxes has made one warmer and the other cooler.

Even shades of white and black can be classified as warm and cool. For instance, the white paint on your wall may actually contain just a hint of yellow to create a warm eggshell white. Your computer screen emits a cool-blue white.

A　　　　　　　**B**

A flat gray shaded over with red takes on a slightly warmer tone in example A, while the same flat gray shaded over with blue takes on a slightly cooler tone in example B.

COMPLEMENTARY COLORS AND NEUTRALS

All of the colors we've just discussed are either primary colors or secondary colors. The primary colors—red, yellow and blue—are not created from blending other colors; thus, they are primary. The secondary colors—orange, green and purple—can be created by blending together two of the primary colors—red and yellow to create orange, for example.

Complementary colors consist of a primary color and its secondary color counterpart (the secondary color just opposite that primary color on the color wheel). For example, purple complements yellow, orange complements blue, and green and red are another pair of complementary colors. These complementary colors will usually work when coupled, but these combinations are considered very basic and somewhat unimaginative when used in their purest form. Some of the more unusual color combinations provide the most interest.

In addition to considering whether colors are complementary (opposite on the color wheel) or similar (close together on the color wheel), you'll want to be aware of which colors can be used as neutrals.

Beyond the obvious black, white and grays, several other colors can be considered neutrals because they merge well with various color palettes. For example, red, although a strong color, can also be used as an accent color (or neutral) with either warm or cool tones. It will go equally well with an olive green or a slate blue. Yellow is another color that can serve as an accent with several different color palettes. Because red and yellow are also bright accent colors, as well as warm colors, they are sometimes referred to as *adopted neutrals*.

COLOR IS PRESENT IN BLACK AND WHITE

Pure black and pure white exist only in theory. In actuality, when present as an aspect of material objects, every shade of value, even if it appears to be simply black or white, actually contains some color.

In fact, the ability of a pigment to reflect light is what gives the pigment its color. Black absorbs most of the light that hits it; the less light the black reflects, the blacker it appears. White, however, reflects almost all light and therefore appears white.

A white sheet of paper is intentionally milled to be either a warm white or a cool white. A cool white image can be placed on a warm white format to create a subtle white-on-white effect.

GRAYS, GRAYED TONES AND PASTELS

Grays can also be warm or cool, and these subtle variations can create interesting moods, especially

A B

All colors are influenced by the colors placed around them. For example, black can produce a dark and moody quality when surrounded by dark, rich colors, but a bright and festive quality when surrounded by bright, iridescent colors.

when combined with other colors. Similarly, black is able to produce one mood when combined with dark, rich colors and another when coupled with bright, iridescent colors.

Finally, primary or secondary colors may be altered with the addition of some black (creating more subdued, "grayed" tones), or they may be softened in an entirely different way through the addition of some white, creating pastels.

EXPERIMENT WITH COLOR

Where can you go for color inspiration? Some of the best combinations of color exist in nature. Train yourself to be sensitive to color combinations all around you. Look at fish, birds, insects and animals, as well as observing all kinds of plant life. When you see a unique combination of colors—whether subtle or bright—ask yourself why that color scheme works and try to analyze it in terms of the color wheel.

Using your computer's color monitor is an easy way to experiment with color. Keep in mind, however, that the colors shown on color monitors rarely match process or match colors exactly, so what looks good on screen may not look good on press.

Pantone and other ink guidebooks are used in the industry as the ultimate guide to how the color will look. Use these books to determine exactly what color you want, but always take into account that many inks are translucent and will assume the color tone of the paper on which they are printed.

Once you have explored the potential of value, add color to complete your design. You will find that your design immediately takes on added life and power.

But be careful not to rely on color to "help" a design that needs further conceptual work. Once you have a strong concept and have organized your elements well, the appropriate use of color can breathe life into your design and help it reach its full potential.

WHAT TO CONSIDER WHEN USING COLOR

1 Do the values in your design work, or is color being used to "save" a poor design?

2 Do the colors you've chosen support the idea of your design or detract from it?

3 Is your design predominantly warm or cool? Would a predominantly cool color scheme be enlivened with warm accents (or vice versa)? (Depending on your concept, this may be an appropriate way to add interest.)

4 Have you considered an appropriate use of neutral colors in your design?

5 Would your design work better with the full brightness of color, with grayed tones (colors with the addition of black), or with pastel tones (colors with the addition of white)?

6 Would your design be more visually pleasing by using color sparingly, as sharp accents? Do you have a design that would actually work best in black and white?

7 Is the color palette you've chosen limited and repeated throughout the design? (Unity is sometimes achieved by repetition, including a purposeful, thought-out repetition of colors.)

EXERCISE

EXPLORING COLOR AND VALUE— Color Changes Everything

Effectively manipulating color and value can have a powerful effect on your design. Always keep in mind, however, that while color and value have the ability to enhance a strong concept, they rarely have the ability to rescue a weak one.

There is no particular concept at work behind the simplified "design" repeated in this exercise. I've merely created a grid of 20 circles encased by 20 squares to serve as an unobtrusive backdrop for experimentation with color and value.

Photocopy and enlarge the blank version of this grid (example A) to create at least five or six copies for your own use. You'll also need a number of colored pencils—as a minimum, choose black, medium gray, red, orange, yellow, green, blue and purple (these last six representing each of the primary and secondary colors).

Begin by using only the gray and black pencils—that is, try some experiments using value only before introducing color. First try creating a high-key design (one that is composed mostly of white or gray).

Next try a low-key design (mostly black or gray). Can you lead the eye through each design, using value only? One tactic might be to place a limited number of white (or black) dots in strategic locations in the design.

Next, introduce color into your design. What effect do you get when you mix black, white and gray dots and squares with colored dots and squares? Try keeping the squares gray and applying color only to the dots. Further experiments might include (1) a design using only primary or complementary colors, (2) a design using only

A

B

C

D

E

F

G

H

I

A single design grid can change considerably, depending on the use of color and value. The basic grid (example A) is turned into an example of extreme contrast using only black, white and gray (example B). Using these same values, it's possible to lead the eye through the design, as in example C. (A single colored dot adds additional interest.) When the value of the illustration is low-key, the one colored dot takes on a new emphasis (example D). Using the six primary and secondary colors, it's possible to divide the design by placing warm colors with warm colors and cool colors with cool (example E). When warm dots are placed over cool squares, as in example F, the design takes on renewed interest. By transitioning warm colors to cool colors, it's possible to create an interesting blend of color (example G). Notice the contrast that is achieved in example H by placing one warm dot on a background of cool dots and squares. Example I shows another random design created through the use of color.

three colors that are adjacent to one another on the color wheel, or (3) a design consisting only of colored dots, each placed on a square of a complementary color.

These examples provide only a few of the infinite possibilities when mixing color. If you began to use colors that are blends of the colors on the color wheel, or pastels and other more subtle colors, you could spend hours creating interesting combinations even with a design as simple as the grid in this exercise.

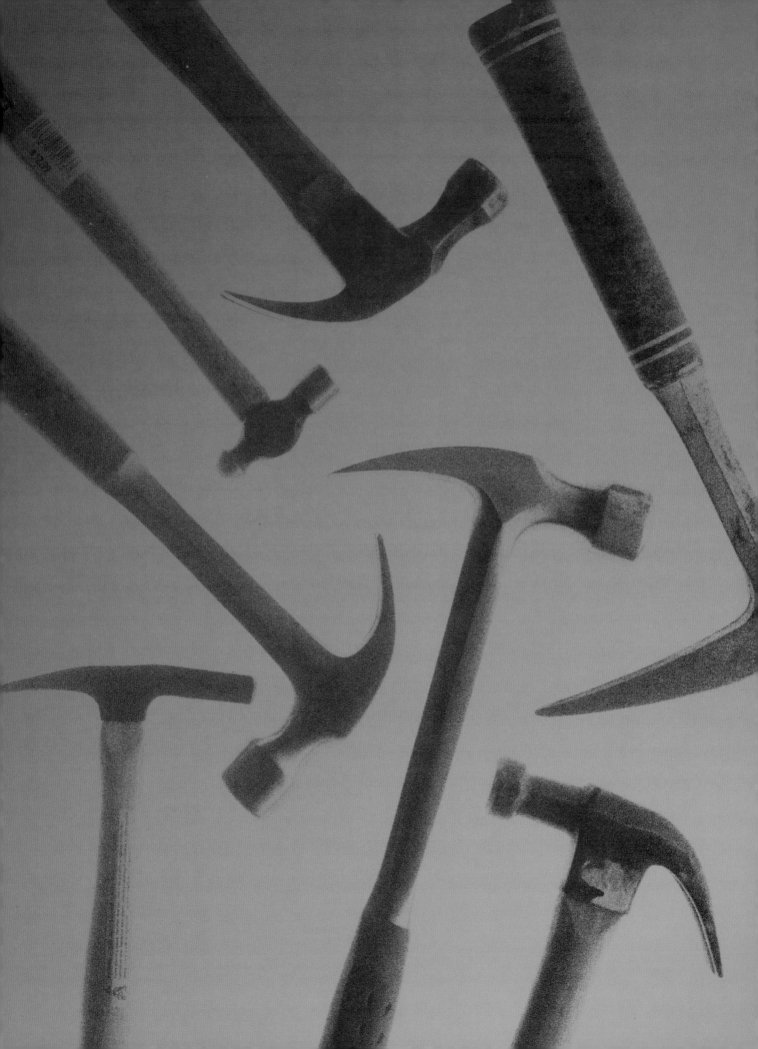

Part Two

Part Two demonstrates design elements and principles in action. Real-life examples show how design skills discussed in Part One are used in actual designs. Sections in this part of the book correspond to the sections in the first half: first covering the elements of design, and then the principles.

While I purposely chose work that predominantly displays the use of one particular element or principle, it's a rare work that exclusively demonstrates a single element or principle. For example, while a design may show use of line as the primary means of communication, there will most likely be other elements used as well, and of course these elements are applied using the basic design principles.

The captions for each design discuss that design primarily as it relates to the predominant element or principle. In most cases, I also provide a discussion of other elements or principles that are at work in the design to further your understanding of how the various aspects can work together to strengthen the concept of the design.

Hopefully you will be able to see how the skilled designer uses the very things you learned in the first half of the book to create great visual design that reaches its full potential.

Line

Swan Poster

McRay Magleby

BYU Graphic Communications

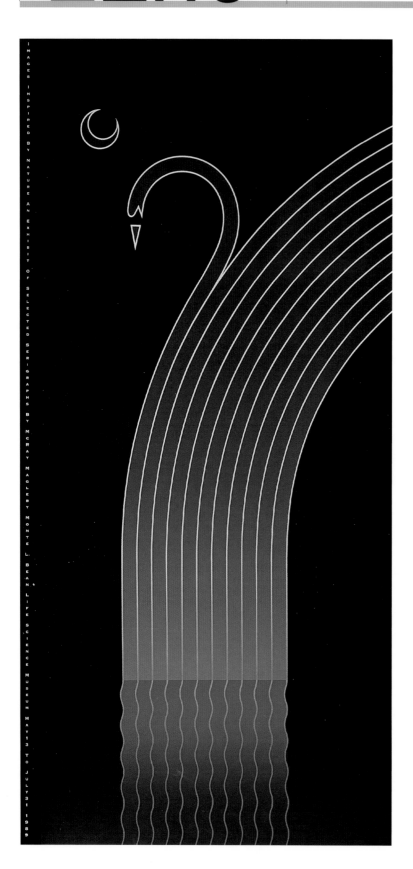

This poster shows how just a few strokes of line can be used to effectively illustrate a swan. While the lines do not adhere to the anatomy of a swan, the image is unmistakable, and the simplicity and grace of the lines convey a feeling of tranquility. There are no excess lines—the poster has just the number of lines needed to communicate the image. Particularly successful is the use of wavy lines to communicate a reflection on the water. Type is used sparingly, and only to provide needed information to the viewer.

There are also several powerful principles at work in this poster. One is contrast: The lines are printed in silver ink on a predominantly black background, which gives the lines a shimmery quality and adds to the elegance of the design. The same silver on a white background would not have nearly as much drama. In fact, the blend of color as the swan meets the water actually gives the poster dimension, even though the swan is drawn as a two-dimensional figure using flat graphics.

Also notice how the moon and type serve as elements of balance. The wavy lines are centered exactly at the bottom of the poster, and the moon and type, along with the swan's head, counterbalance the silver lines as they veer to the right on the upper half of the poster.

In contrast to the consistent line in the swan poster on the facing page, this poster utilizes a loose, erratic line that communicates an entirely different mood. The black line spirals inward and is very effective at capturing the eye. Only upon reaching the center of the spiral does the viewer discover a second snake in the negative space between the black lines. This use of positive and negative space (a type of contrast) creates a simple, yet powerful, design. The poster, created entirely with the simple use of line, is hypnotic.

Additionally, the design almost has to be black and white, since this ultimate use of value contrast serves to strengthen the impact. Notice, too, the reserved use of colored type in the upper left-hand corner; the poster needs no more color than that to communicate.

This annual report uses line as an organizer. The design employs a very simple grid consisting of a die-cut square placed directly in the center of the piece. This visual element echoes the concept (and title) of the report: "Outside the Box." Lines radiate around this square on the cover and on subsequent spreads to organize images, words and thoughts, and to create ideas.

This simple use of line, in conjunction with elements of type and shape—the square itself and photographic shapes—creates the basis for communicating key concepts to the reader. Notice the restraint the designer uses, providing just enough information to communicate while keeping the design clean and simple.

Both of these posters use the simplest form of communication—
simple, unadorned line—to communicate big ideas. Type is used
very sparingly, and virtually the only shapes to be found are those
created by the lines themselves. The paper is pure white, the lines
are black, and no other color is permitted to get in the way.

The first poster above left is very symmetrical, with only the slight-
ly off-center position of the rocket pieces to violate perfect symme-
try. The second poster above uses type in the corners to anchor the
design, and a single asymmetrical image to create interest.

Even though the execution is the ultimate in simplicity, the ideas
are clever and quite memorable.

Peace Poster
McRay Magleby
BYU Graphic Communications

It's difficult to attempt an analysis of this poster in regard to how it uses any single design element or principle, since it uses so many aspects of design effectively. Certainly, without the lines in the water, the image would lack depth and movement. On the other hand, there is clearly a use of line to give shape to the ocean, and this shape is central in the poster's design. Given the concept, it isn't necessary for the type to be any more complicated than it is.

It's interesting that the poster feels balanced, even though it does not possess perfect symmetry. The orange in the lower sky effectively balances the whiteness of the wave. Since the wave is moving to the right, it is placed to the left of center to visually balance the design. What really carries the poster is a very powerful idea.

This letterhead identity is a good example of line carrying a concept. The idea is simple and its execution is effective. A stone is placed above the type to reflect the word *stone* in the name. A flowing calligraphic line is drawn to indicate the image of a cook, adding an elegance to the design that is in direct contrast to the image of the stone. The viewer can even see the image of a ladle with steam rising above it. All of this is communicated through the simple use of line.

Like several other designs we've seen (on pages 82 and 83, for example), the design is very restrained: No additional embellishments are needed. Even the type is very simple, with just the tasteful addition of a decorative *K* in the word *kitchen*. The color choice for the type is also appropriate, providing a pleasing contrast to the color of the stone.

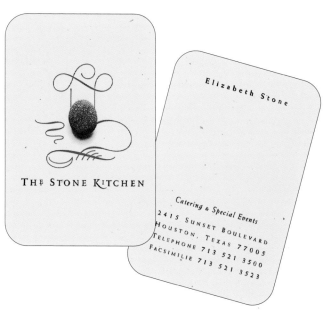

This design provides a great example of line used as an organizer. The cover is divided by three lines, each enhanced with one of three identical shapes at the top, to create a very symmetrical feel. To add interest, a plant stem and folded piece of paper are placed across the grid. Notice how similar lines on the inside front cover are used to imitate the feel of the plant stem on the cover.

Inside spreads repeat the same vertical line that appears on the front of the piece to provide a grid for the type. Other photographic objects are placed in the format over the grid line (as the plant stem is placed on the cover) to break the grid and add interest to the page. Even the full-page photographs have a linear quality about them that complements the structured feel of the brochure.

In contrast to the posters on page 83, both of which use a simple, singular line to communicate the concept, here the designer communicates with multiple lines defining shapes. The quality of the lines is very loose, and creates an effective background texture for the slide frame, which becomes the focal point of the poster. The pattern of lines alone creates a flat image, but when the pattern is coupled with the image of Seymour Chwast (poised atop a small hill) peering from behind an oversized slide frame, an intriguing dimension is added.

The slide frame is the only element that is printed in white, and so it immediately directs the eye to the discrepancies in perspective. The type serves to visually continue the frame that the lines create. In this way, the type is but another configuration of lines that support the concept.

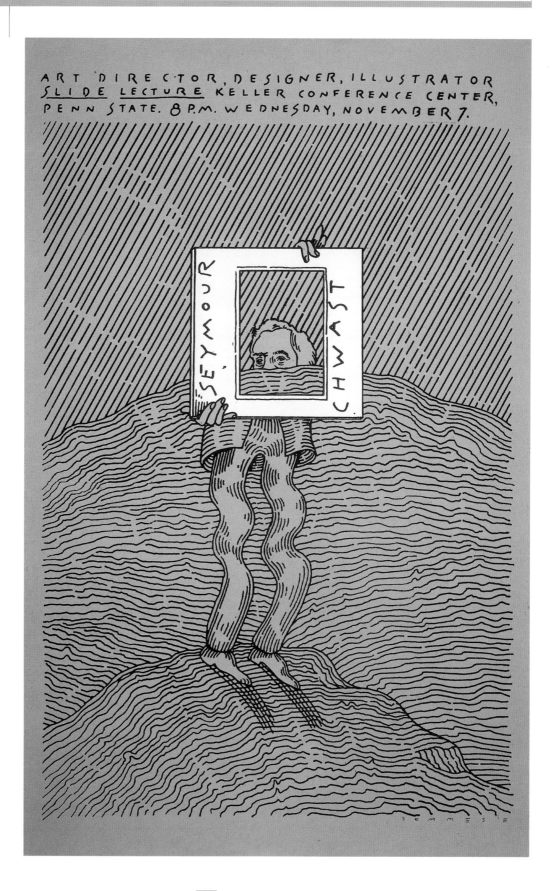

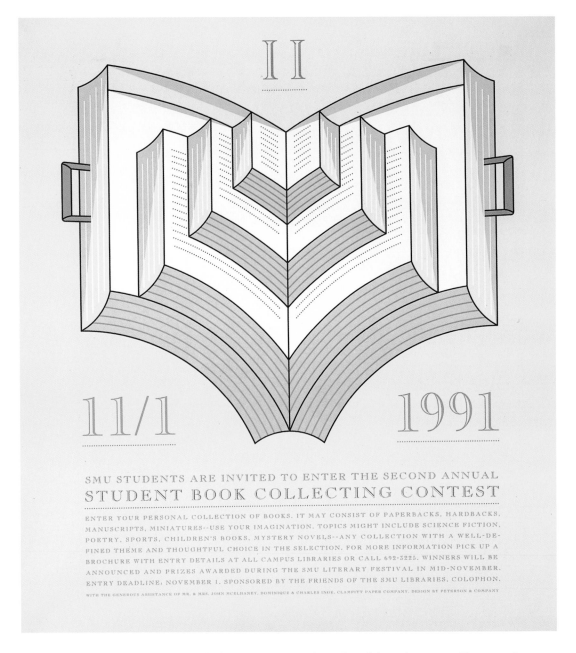

In this example, the lines that create the image are very consistent in weight and structure. The poster is absolutely symmetrical, which strengthens the idea of an opening portfolio containing layers of books—a small one atop a larger one atop a larger one still. The simple lines inside each book give the impression of pages of text and so help identify the shapes as books. You might say the lines define the image and the color adds dimension. Even the type is positioned to reinforce the symmetrical balance of the poster and to enhance the line illustration.

The values of this poster are high key, meaning predominantly light in tone. Every element, from the weight of the lines to the color choices, supports the feeling created by the high-key value.

The weight of lines used in this poster is very consistent, as it is in the Student Book-Collecting Contest poster on the facing page, but the way the lines are used is different. Rather than being noticeable elements on their own, the lines here are used primarily to trap the colors in the face, hair and hands of the woman who appears as a part of the night sky. In direct contrast to the previous poster, this poster needs to utilize dark values to communicate a starry night sky. The subtlety of the woman is contrasted to the image of the Earth being cradled in her hands. This contrast is responsible for the success of the poster.

Notice also the balance of the design. Because the woman is subtle, the poster immediately feels very symmetrical, since the position of the Earth is almost central. However, beyond the position of the Earth and the rectangle housing the illustration, the poster is actually somewhat asymmetrical.

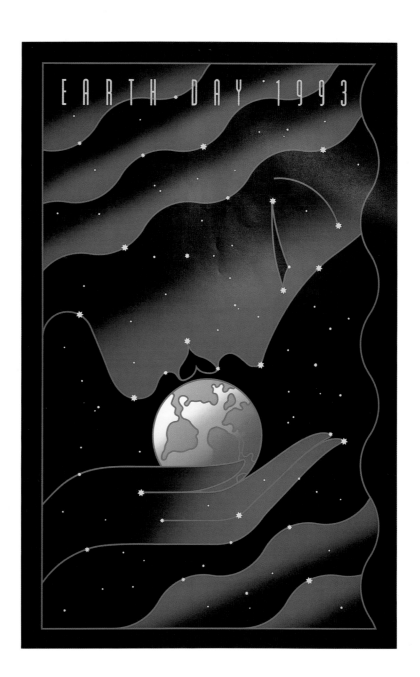

Type

In stark contrast to the typical slick, glossy and often expensive look of an annual report, this one uses no element other than type. It is printed on a thick, carton-like paper using only black ink. The font used on the front cover and left-hand pages on the inside spreads, Courier, is usually considered to be a Macintosh default font. But this very simple, easily readable typeface seems appropriate considering the title of the book, "back to basics."

The Wire-O-Bound cover also reinforces the concept and adds to the simple, even austere, look of the design. The centered statements on the left-hand pages carry the key messages of the report, while the explanatory text on the right-hand pages is also relatively large and easy to read. As a final touch, the financial section of the report is printed on paper similar to what you might find a bank draft on, again stressing the concept of financial information reported in a simple, straightforward way.

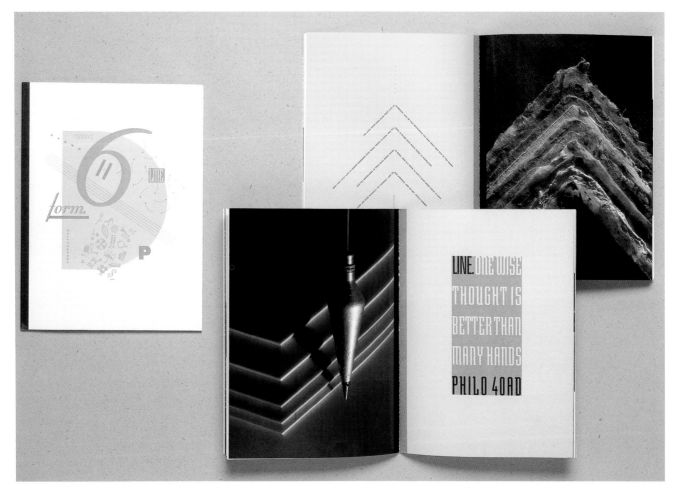

This photographer's promotional brochure uses type to reinforce the concepts of the photographs on each spread. In many cases, the type is even used to add definition to the image it's displayed with. You've heard that a picture is worth a thousand words; here you see how just a few printed words can expand the meaning of a photograph. The cover of the piece uses typographic and visual images from various pages in the brochure.

Notice how the type pages are printed in two basic colors: The backgrounds are always light green, while the type and graphic elements are printed in either dark green or black. These relatively subtle colors function as neutrals; when these pages are placed next to multicolored photographs, they tend to emphasize the color in the photos without detracting from or clashing with them. In the center of the book the design employs a black bar on the photo side placed next to a green bar on the type side. This simple element ensures that there is always a buffer between the type and the photo.

Much like the brochure on the previous page, this brochure places type and photo images on opposite pages. Although the type receives a similar treatment on each page, and is in roughly the same position on most pages, the brochure maintains a high level of interest through the subject matter of the photos and the unconventional treatment of the type. The type is overlapped, given a drop shadow, modified in size and color, and highlighted with an opaque white ink on different paper colors.

Notice how the type is placed almost right up to the left and right trim of the piece. While at first glance this violates a rule of design by not giving the type a large enough margin, this treatment is very effective in adding to the tension that the type is trying to communicate. This is a good example of how rules are meant to be broken—but only in the service of furthering the concept.

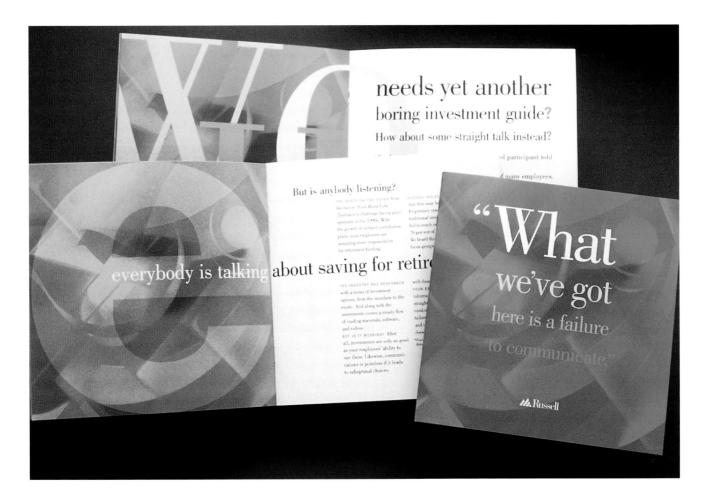

This brochure uses type as its primary visual element. By modifying this type on the computer and giving it dimension, the design is able to hold the attention of the reader almost entirely through the use of the type alone. Another successful aspect of the way this type is used is the varying type sizes that serve to lead the eye of the reader; for example, notice how the decreasing size of the type on each succeeding line of the front cover leads the eye downward and almost into the rest of the brochure. As the reader turns each page, she is drawn in first by the main message, which appears in just a few words set in very large type, then on to copy set in smaller and smaller type, ending up at the body copy.

Varying the background color of each of the pages that showcases the modified type also plays an important part in maintaining the interest of the reader.

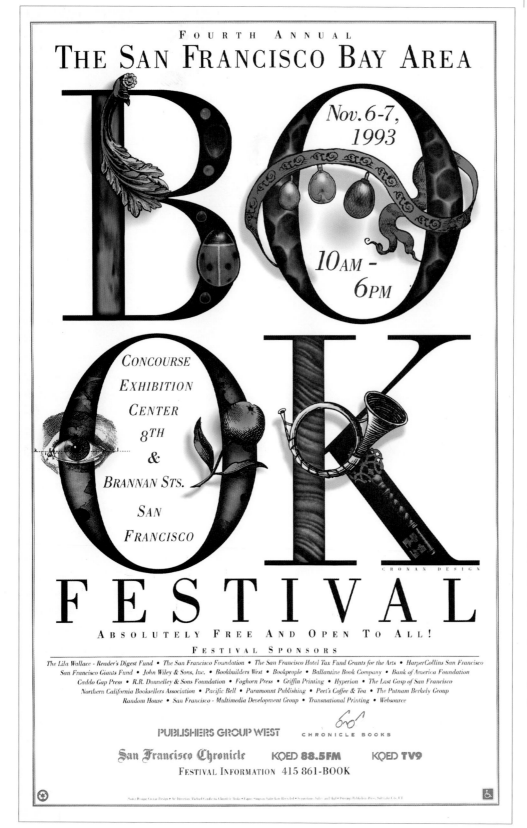

Every element in this poster is centered around the type. In fact, the poster is predominantly a single, appropriately "bookish," typeface (Bodoni) used in roman and italic. The animation of the word *book* through placement of the few images right on top of those letters is especially effective in reinforcing the concept of exploring different subjects through books. The contrast in type sizes, from huge, illustrated letterforms to small type for information, adds further interest to the poster.

Other elements and principles were also carefully utilized. For example, the white paper the poster is printed on adds to the design's literary feel, and the fact that color is used sparingly shows an appropriate restraint; for instance, note the limited use of color in the four main characters. The largely symmetrical placement of elements further adds to the feeling of sophistication and elegance that is appropriate to the subject matter.

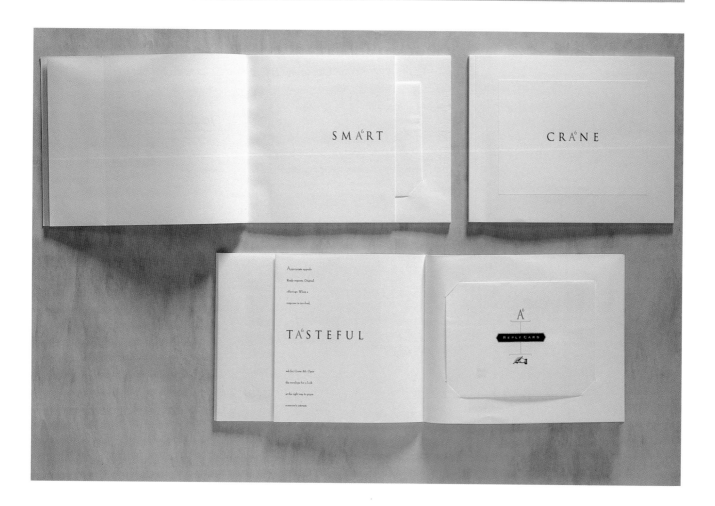

I included this simple paper promotion because it's carried successfully by a single idea that's expressed almost exclusively through type. The purpose of the piece is to promote a new Crane business paper called A6, and the use of A^6 in every major word in the piece is a great way to visually reinforce the name of the paper. The A^6 type is separated from the other letters by the use of red for these two characters throughout. This type is always placed in the same position on every page. Other nice touches include the use of engraved type throughout and the placement of an embossed rectangle on the cover of the brochure.

This design is elegant and unembellished, proof that the simplest design is often the most powerful. Try to take every element you can out of your design until it carries just the essence of the idea.

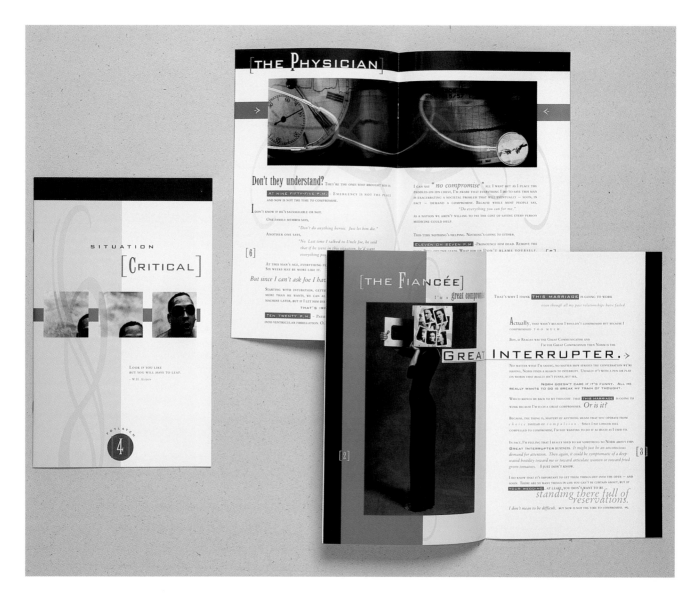

This brochure uses type in an unrestrained, freeform fashion. There are several families of type here: Serif, sans serif and even sans serif words with serif caps are used. Utilizing faces that are contrasting yet compatible breathes interest into the design. The type is clearly the star of this design, with most of the photographs taking a back seat.

While type is used to give the piece interest, unity is provided through the use of color. The tan, metallic burgundy, dark green and black appear in differing strengths throughout the brochure. One page might be solid black with typographic accents, other pages predominantly white, and other pages divided by solid tan and metallic burgundy. This change of color provides a rhythm to the design. In addition, the designer has utilized boxes, calligraphic shapes and underlines to create a lively design.

The type on this magazine cover is used more as an illustrative element than as an element to convey textual content. The designer rendered the type on the computer with the intent of having it serve somewhat like a pictograph. The type is both "flipped" (backwards) and "flopped" (upside down), then these two images are connected by the *i* in *idea* to create an unusual, mirror-type effect. That the type is not readily readable only adds interest and intrigue to the design.

The concept of "idea" is reinforced with the image of an egg, which is enhanced by several effective additions. The halo around the egg gives the design a mystical feel; the textures in the photograph add warmth to the image. The colors themselves are complementary and blend well. The decision to reverse the type to white out of the photograph softens the type and prevents it from fighting with the image of the egg.

Shape

Quintessence Paper Promotion
Bob Goebel
The Kuester Group

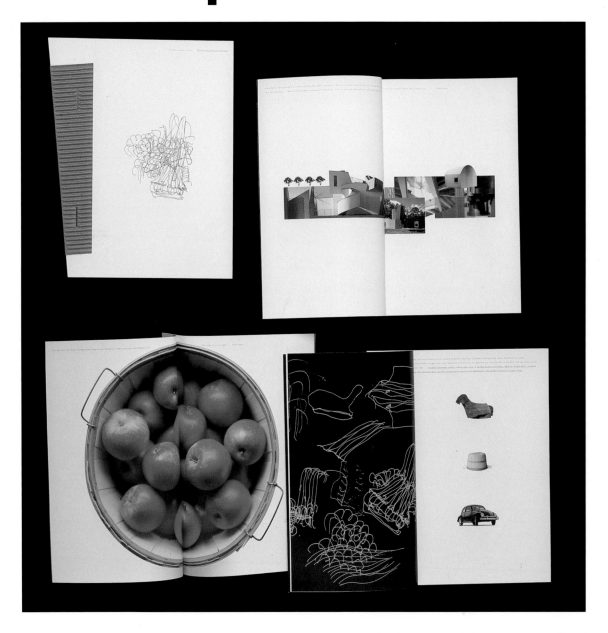

This paper promotion shows how shape can be used as a creative statement in several ways. The first thing a viewer notices about this piece is the unusual shape of the format itself. The irregular shape and size of the piece is complemented by the unusual method of binding—a piece of corrugated cardboard wrapped around the pages and held with industrial copper staples. Not only is the cover built on shapes, but the interior is likewise a combination of shapes that hold art, type and photographs. Some of these shapes are squares or rectangles, others are out-line shapes of the objects themselves. One spread uses shapes put together to form an architectural illustration.

Notice the contrast of shapes used, as well as the various sizes. On some pages you have very small shapes, while others show one huge shape, such as the photograph of the basket of apples. If the shapes were all the same size throughout the piece, you would tend to lose the reader's interest. As it is, each page holds a surprise.

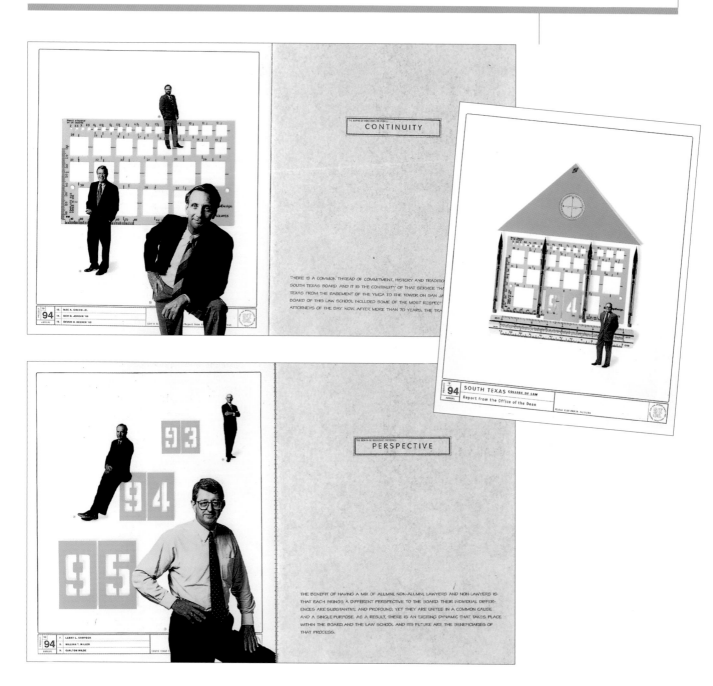

This piece uses shape to communicate the idea of planning and building. The concept is conveyed immediately with the cover illustration—a building, created from templates, rulers and mechanical pencils, coupled with the portrait of the dean of the school. Throughout the piece, these same tools are pictured, along with portraits that introduce ideas and key players. These portraits and other shapes are most often provided as a simple outline of the subject against a white background, giving great emphasis to each photo.

The designer also carried through the idea of planning by using an industrial-looking sans serif face for the body text and by adding the textures of blueprint paper and vellum for the title pages. The typography is very simple and entirely appropriate, as is the use of black-and-white photography. As you design, try to carry your idea through the entire piece without getting unnecessarily decorative. The idea truly drives the design of this brochure.

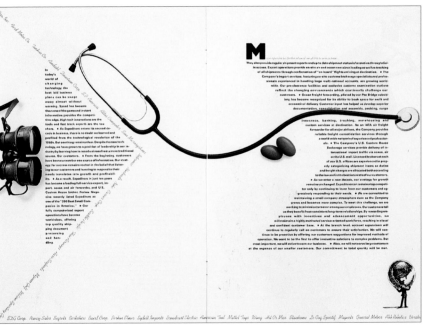

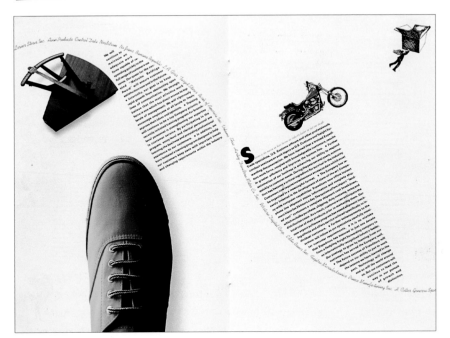

Not only can shape be used effectively in photographs and with other art, but this annual report shows an outstanding use of shapes created with type. These typographic shapes are carefully combined with photographic shapes to create an intriguing layout.

The designer let various photographic images create their own shapes and then complemented them with well-planned typographic shapes. Each spread is constructed with these basic shapes as the basis of the design. Notice in particular how the stethoscope, pills and binoculars are intertwined with the shapes of the type to activate the format. Also notice the amount of white space used on the cover and on the spreads. This "luxury" of space is actually a necessity to make page layouts that are easy on the eye.

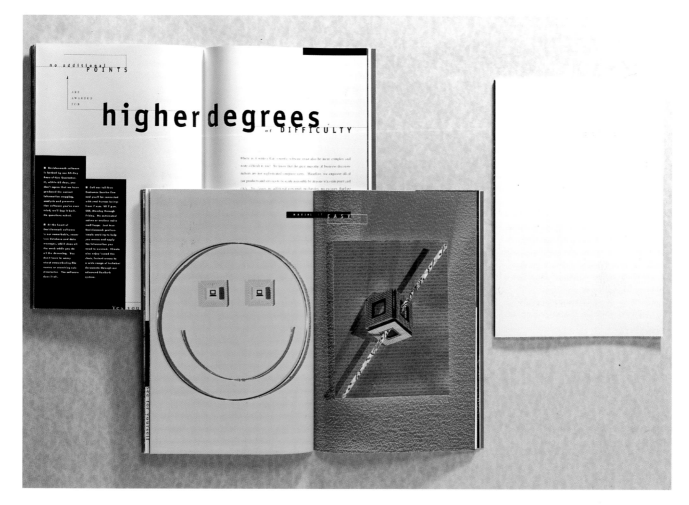

Spreads in this brochure alternate between typographic configurations and photographic combinations of shapes. The type-dominated spreads are a combination of line, shape and type. On these pages, blocks of type are used to create shapes that are interesting in and of themselves, but also serve the purpose of breaking up the text into more appealing, easily readable chunks. Lines are used to connect the various type blocks and other shapes.

On the photographic spreads, the designer uses shapes, along with color combinations and textures, to create a visual feel that contrasts sharply with the starkness of the type-based pages. Type on each of the photographic spreads relates to the message communicated on the preceding type spread.

Duffens Optical Brochure

Sonia Greteman and James Strange

Greteman Group

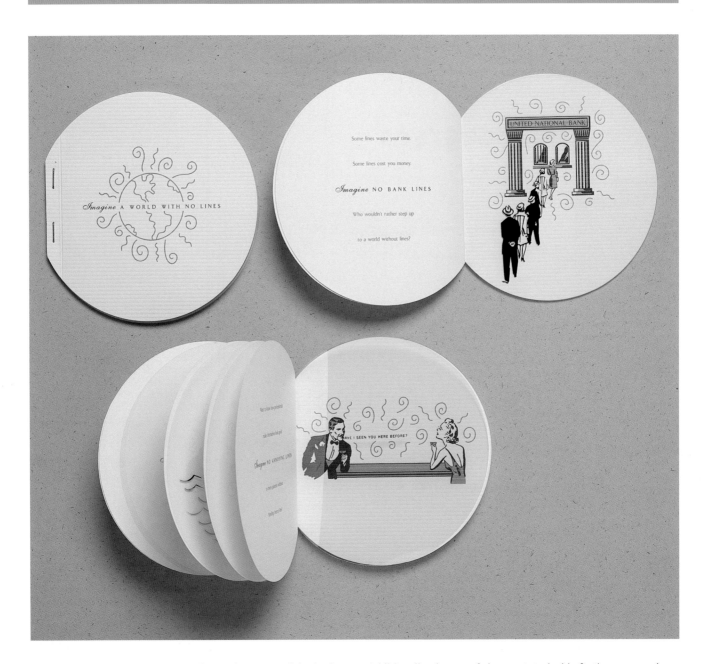

This uniquely shaped piece communicates the nature of the business instantly—the format of the booklet, when open, is roughly the shape of a pair of eyeglasses. Closed, the cover looks something like an eyeball, complete with a pupil shaped like the Earth.

Additionally, the use of clear acetate inside further communicates that this is all about eyeglasses. Since the booklet promotes a new "no-line" bifocal lens, the designer plays with the concept of lines vs. no lines throughout the booklet, with annoying lines of all kinds (bank lines, static lines, etc.) being removed from the illustration when the acetate page is lifted up. The choice of paper, a grooved text, also emphasizes the concept of lines.

This brochure uses shape and texture to sell furniture, which itself is judged by these two qualities, among others. Even the photograph of the president of the company is surrounded by interesting shapes and textures that suggest fabric swatches appropriate to furniture. The effect? A brochure that brings the viewer's eye into the piece to inspect the products being sold.

The structure of each spread varies. Sometimes the designer uses a grid, at other times he uses a free-form shape (or shapes), and at still other times a single dominant image is surrounded by less important shapes. With this relatively complicated design, the grid is not immediately obvious, but it provides a subtle thread running through the design. In every case the layout avoids clutter, with all shapes and textures supporting photos of the product. The type is secondary (almost incidental) to the furniture and shapes surrounding it. The design is both entertaining and informative.

Harper College "Unity Through Diversity" Poster
John Sayles
Sayles Graphic Design

Nearly every element in this poster is contained by a shape. These shapes are then interlocked to add cohesiveness to the design. Also, notice how the two shapes that contain the headlines are used to frame the design at the top and bottom. Because these shapes work together, the poster design works as a whole. One thing that adds interest to the design is having the typography contained within certain shapes but violating the borders of other shapes.

Color and type are also used well in this design. Notice how the green is placed strategically throughout the design, both to add interest and to hold the design together within the format. The type not only serves to inform, but also acts as a texture and an art element. For example, the different styles of type serve to strengthen the concept of diversity. The poster is printed on brown bag paper, which further adds to the mood of the design.

This poster takes something as simple as a sheet of paper and makes it the star of a Broadway show. There are five basic shapes at work on the poster—the letterhead (which functions as a face), the hat, the eye (which is actually a "certified" seal), the paper clip and the spotlight. It's the subtle addition of the spotlight that completes the image and communicates the concept. Even the simple addition of a paper clip as a nose helps define the image of a carnival barker and brings the inanimate letterhead to life.

The color in this poster is very rich and strengthens the show business theme. The yellow spotlight lighting the hat and the letterhead is complementary to the red of the background. The typography is reminiscent of typewriter type and adds to the playfulness of the design, while also reflecting the type that is printed on the letterhead itself. The design is nearly symmetrical, except for the slight angle of the character and the spotlight.

Texture

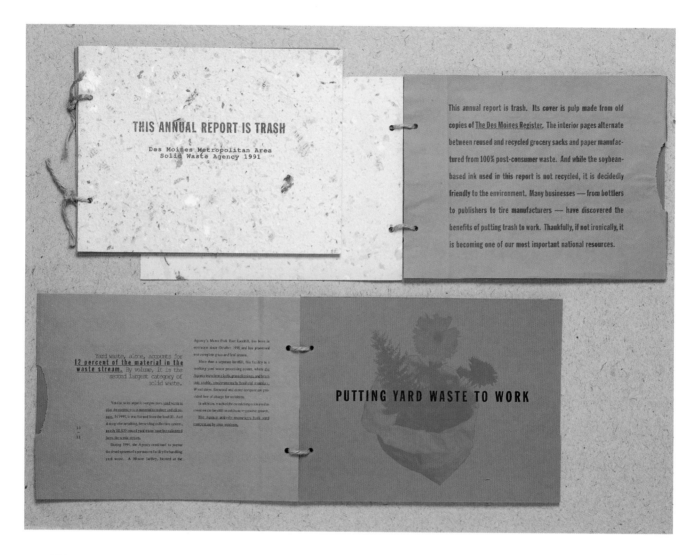

I would be hard-pressed to find a piece that makes better use of texture to communicate a concept than this annual report, which also serves as a promotion to encourage individuals to recycle. The cover uses recycled paper that's made directly from recycled trash, and the brochure is entitled "This Annual Report Is Trash." When the front cover is turned, the viewer reads an introduction printed on an actual paper bag, complete with jagged edges. The other paper used in the report is a more mainstream recycled text sheet. The brochure is bound with two pieces of twine.

This combination of binding and papers, along with the use of only two colors of ink—black and purple—creates a design that is direct and simple, and that conveys the concept through the materials used to create the piece. The type is appropriately simple.

This promotional brochure for Weyerhaeuser papers features portraits framed by various contrasting textures. These "picture frames," or borders, consist of photographs of mostly rough or unusual textures, such as corrugated cardboard and oil-stained paper, each contrasting with the portrait inside of it. There's a picture of construction workers, for example, framed by the remains of a developer pack (the kind used in instant photography).

Occasionally, three-dimensional objects are placed on top of these textures to create an additional textural layer. In one spread, for example, a bright red tomato is placed on top of layers of cardboard to create an unusual but interesting contrast. Since the brochure was designed for a paper company, these textures layered one on top of another are used to communicate a fondness for the textures of different papers.

The use of textures in photographs can be quite effective in a design. This brochure takes a look at various aspects of the Phoenix Fire Department, and especially the use of Dalmatians as "Fire-Pals." It is appropriate, therefore, that the cover consist of a close-up shot of a Dalmatian's fur. Inside, various textures typical of a fire department are captured in prominently displayed full-page photos—from fire hydrants to the chrome handle at the end of a hose.

The design follows a grid of three narrow type columns, with bold type appearing in the column closest to the photos. The use of a straightforward, stenciled type on the cover and for the section openers lends a practical appearance to the brochure. Also note the use of a simple, classical face for the body text. When choosing type, always consider whether the faces you want to use will be appropriate. With a serious subject such as this one, decorative faces would be out of place.

Bryan Peterson

Peterson & Company

This annual report was designed to communicate the financial status of MADD and satisfy donors that donations are used wisely within the organization. To help convey this concept, the entire report is done to look like a ledger. The cover consists of a composite of two shots—a metal ledger binding and a canvas texture. Inside the report, the "Message from the President" is printed on a simulated ledger balance sheet to further carry forward the theme of responsible financial stewardship. The textures in this piece are critical to communicating the serious concept.

Also notice how sparingly color is used. Besides the full-color shot of the metal binding on the cover, all other photography is black and white. Use of color in the graphics is also limited.

The focal point of this promotional brochure for the Houston Zoo is a series of full-page (and even full-spread) close-up photographs of different animals that live there. The textures of the animals—displayed to give a "larger than life" feeling—instantly communicate the variety of the zoo and at the same time give the reader a very tactile, immediate feel for the mood of the zoo. The cover of the piece is wrapped in crepe paper and sealed with a tipped-on label identifying the brochure, so the textural aspect comes into play as soon as the reader sees the piece. When the wrapper is opened, the viewer is met with a photo-graph of a zebra's fur. Even the text paper, a parchment, reinforces the textural feeling of the brochure.

The text type is large, with color-illustrated decorative caps to start each section. Additionally, there is a timeline that runs throughout the text on the outer margin. Although there are many different elements—illustration, photography, text and textured papers—all of these elements are skillfully combined to convey the mood of the zoo.

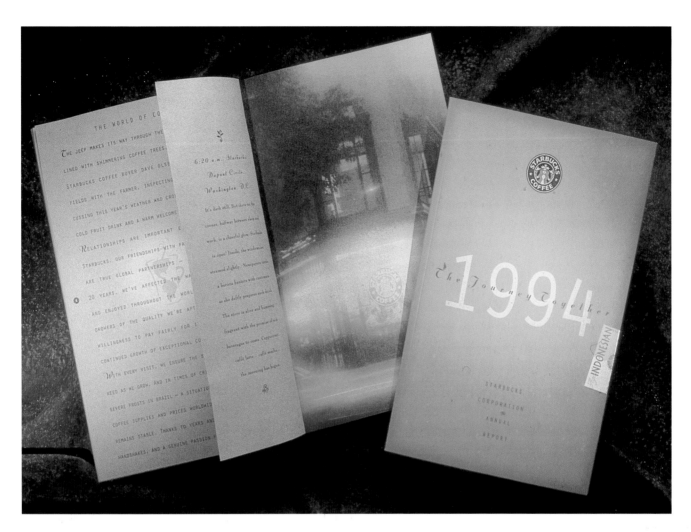

As an annual report for a coffee company, it seems appropriate that this piece should have such a feeling of casual warmth. Inviting, slightly grainy photos portraying Starbucks coffee shops, and customers with steaming cups of coffee, provide one layer of warmth and texture. Another layer is provided by the warm-color, smooth-texture papers these photos are printed on. Short sheets, each with a brief, coffee-related story, are placed throughout and add dimension to the design, allowing one more level of tactile communication with the reader.

There are also spot illustrations that provide a contrast to the grainy photographs, but contribute in their own way to the casual, friendly appearance of the annual report. Every element, including the skillful use of typography, works together to give the reader a feel for a company that's passionate about coffee.

Balance

AIDS Poster
McRay Magleby
BYU Graphic Communications

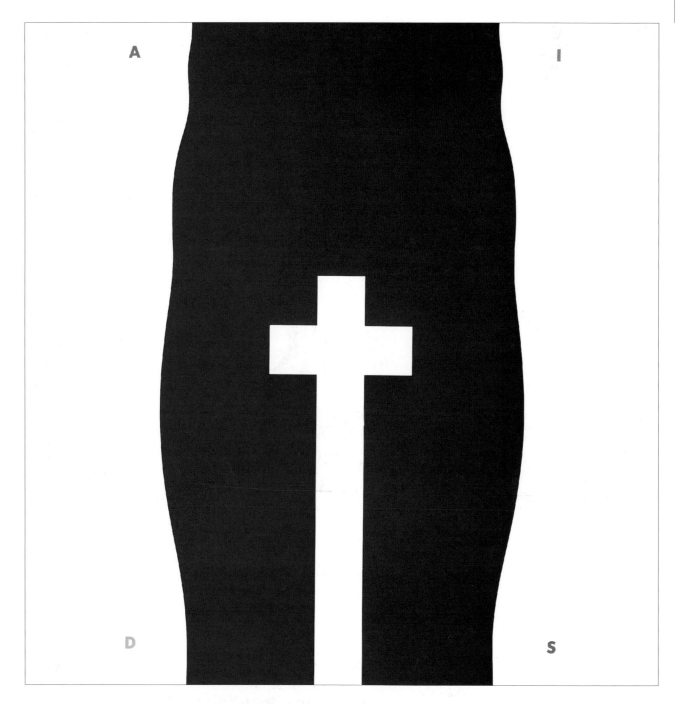

The right and left sides of this poster are perfectly symmetrical except for the subtle color change in each letter of the type. The design is very simple—and powerful—because the concept of the poster is instantly apparent. Any other embellishment of the art would have distracted the viewer from the simplicity of the concept. The fact that each small letter of type is a different color is a subtle touch that adds dimension and interest.

The principle of contrast is also at work in this poster. The pure white of the cross stands out perfectly against the black of the body shape.

These two posters for the California College of Arts and Crafts are both examples of symmetrical balance, but with very different approaches. The poster to the top right is relatively simple, and is the more strictly balanced of the two. Divided into four equal quadrants, the design centers on a single, centrally placed figure that's almost perfectly symmetrical, except for the different objects in each hand. Built on a very strict grid, the type is also symmetrical. Slight variations in color and in the illustration provide just enough relief from the nearly perfect symmetry.

The poster to the bottom right is more complex and, for that reason, intriguing. While the design is fundamentally symmetrical, many elements within this basic structure are asymmetrical. For example, the central building in the illustration, and all of the type, is placed around a central axis. But all of the other structures in the illustration are not symmetrical. The seven circular peepholes are centered, along with the man that looks through the center one. But the images inside the peepholes are different. Likewise, the six columns of type are centered, but different in length and color. The balance of the poster gives it a very stable feeling, while the subject matter, color and texture of the elements add interest.

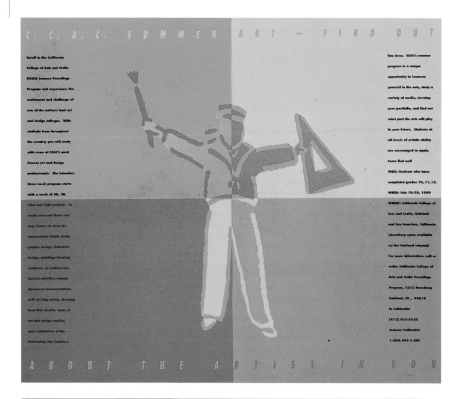

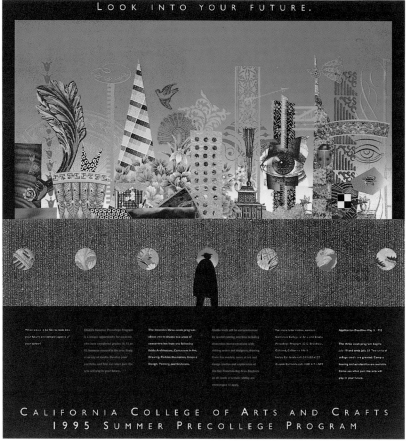

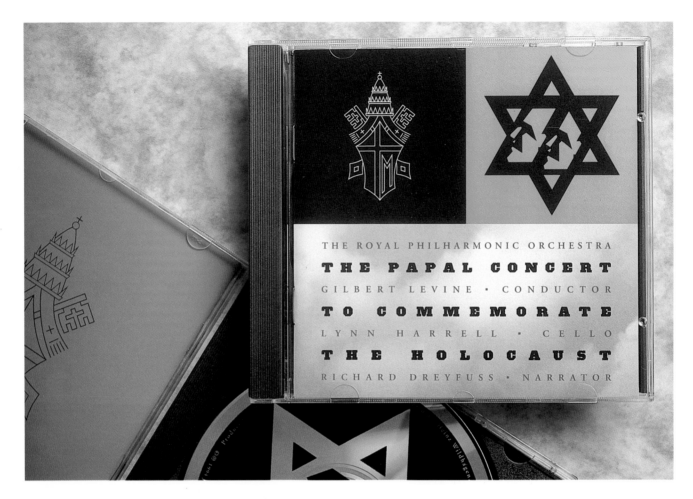

This CD design is built on a mostly symmetrical grid, but the images and colors placed in this grid are asymmetrical. The top half of the design is symmetrical (right to left) by virtue of the two same-size squares, but interest is created by placing one graphic illustration on a field of yellow and reversing another image out of black. The bottom and top halves are not symmetrical in relation to each other, but placing the type below the two images serves to cushion the rest of the design as well as to inform. Consequently, the design feels balanced while not necessarily perfectly symmetrical.

This piece uses a strict balance; while not completely symmetrical, it feels as if it is. The pens jump the gutter of the brochure on almost every spread, and are essentially centered. The exception is an occasional type page where the type is juxtaposed opposite a full-bleed photograph. Type on the photo spreads is used sparingly and consists only of a small word printed in script type. This places the focus of these spreads right on the illustration of each pen.

The horizontal format of this brochure lends itself perfectly to the shape of the pens that are the subject matter of the piece. This is a great example of using a carefully selected format to add power to the idea.

This poster is a good example of a balanced design that is almost completely asymmetrical. The only element in the design that is symmetrical is the bowling pin at the center of the image. (The right and left sides of the object are symmetrical, plus the object is centrally placed.) This pin acts as an anchor to allow the other shapes, typography and textures to float in the format. While the placement of these other objects isn't symmetrical, balance is achieved through careful selection and placement of each object. Also notice how the black shapes on the borders of the poster line up with other elements within the design.

Another unifying aspect of the design is the limited color palette. Repeating the use of neutral colors, such as red, helps tie the different sections of the design together. The paper color and texture are somewhat visible underneath the translucent ink colors, which also gives the poster a unified appearance.

There's an interesting grid working in this CD cover design. It basically consists of a centered horizontal line and a slightly off-center vertical line crossing almost (but not quite) in the center of the design. This divides the area into four nearly equal size quadrants, providing not only vertical but also horizontal symmetry. Notice how the photo is not only mirrored top and bottom, but is nearly symmetrical left and right as well. The type is centered left and right, too.

While the beautiful symmetrical balance is the first thing you might notice, there are other factors at work in this design. Contrast is used in several ways—note the black-and-white type and the gradation of shading from the center of the piece to its edges, getting darker and darker until it fades to black in the corners. This effect powerfully enhances the mood of the piece. There's also a noticeable texture in the background of the photo, which adds to the overall feel.

Contrast

Norcen Annual Report
John Van Dyke
Van Dyke Company

This annual report design gets a lot of its impact from the use of strong contrasts, particularly by making maximum use of black and white. The black-and-white shots on the photo pages are displayed in varying sizes and shapes on either solid black or solid white backgrounds. This use of stark black and white, combined with the unpredictable photo shapes, gives the brochure a dramatic feel. The varying size of the subject matter within each shot— from close-ups to shots that present the object quite small and far away—also adds dimension to the design.

Black-and-white photography can be very powerful. Just imagine how much of the effect would be lost in this brochure if the shots were in color. The black-and-white photos also complement the large solid areas on each spread.

This poster is a great example of contrast because it uses nothing but black and white in their purest form. The intent of the piece is to convey a strong message with the help of visuals that are as simple as possible. The love story is visible first in the face-to-face figures of Romeo and Juliet; the tragedy is hidden in the dagger in the heart which appears in the negative space between the faces. The image communicates the idea simply and without unnecessary embellishment, proving once again that the strongest ideas are often expressed best with the simplest execution.

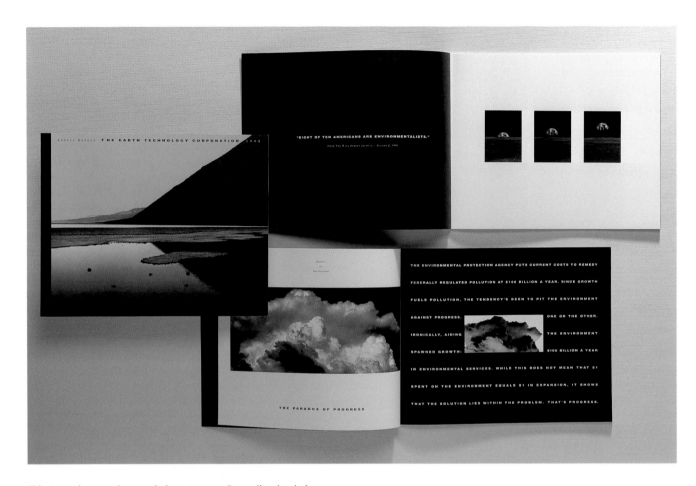

This annual report is a study in contrasts. Immediately obvious is the use of the ultimate contrast in values—the report is done only in black, white and gray, with a lot of pure black and white. The stark images used include the highest quality photos containing the same contrasts and starkness as the rest of the design. One example is the series of photos of the Earth taken from space, emphasizing the small, life-filled globe contrasted against the vastness of space. The typefaces used present another contrast—a heavy sans serif face is combined with a delicate serif face. The booklet is beautifully paced, with both key bits of textual information and images allowed plenty of breathing room on the page.

Other elements at work in this piece are the textures in the photographs, as well as the texture of the financial paper. The book is balanced on an implied horizontal axis that begins on the cover and runs through the center of the design on subsequent spreads.

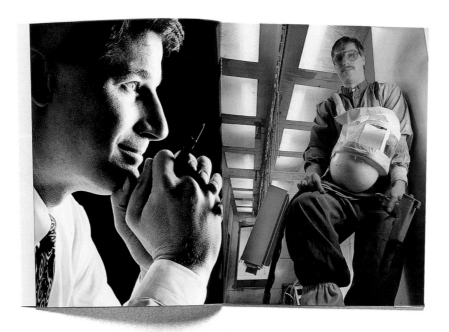

Like Earth Technology's annual report on this page, this annual report for Pentair also uses black and white for dramatic contrasts. In this case, black pages are juxtaposed opposite white pages; in addition, full-page black-and-white photos are positioned next to full-page color photos on some of the spreads.

Type is also used as a forum for contrast. Key messages are reversed to white on solid black backgrounds, then placed opposite text pages that use black type on white as the main form of communication. One final use of contrast in type appears in the surprising variations in size and style. In order to liven up some relatively dry information, important concepts are pulled out in extra-large type or italicized, or both.

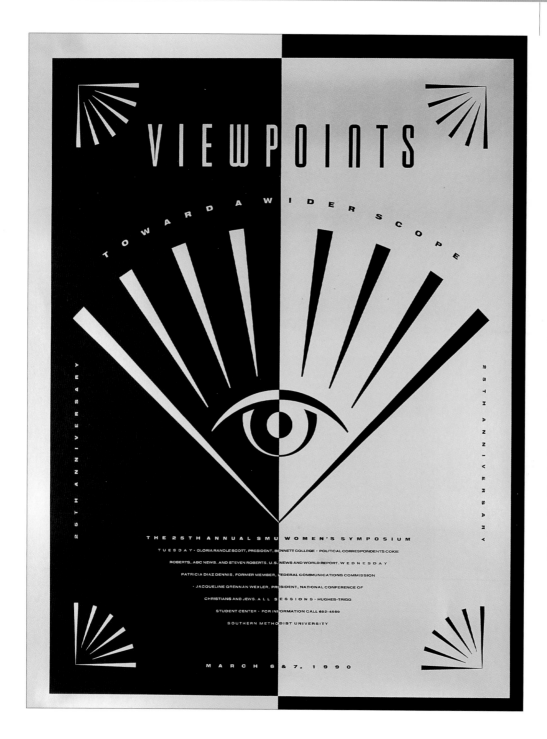

This poster is divided vertically into two halves to communicate the idea that differing viewpoints can sometimes be expressed in the same format. As the eye crosses the centerline, every element in the design switches either from black to metallic or from metallic to black. Contrast is the key to this design, because it's such a strong way—almost the inevitable way—to convey the idea behind the design.

As you try to find the best way to communicate simple ideas, always be aware of the natural solutions; that is, solutions that may be obvious. When properly executed, these solutions can provide the most power for your designs.

This elegant solution to promoting Tableaux Restaurant uses contrast and variety to create a sophisticated, yet lively, look. The mailer, especially, is the epitome of this approach, with its use of different, yet complementary, images and elements, including a leopard-skin pattern, stylized sun images, metallic bronze with olive green, Chinese type and English with calligraphic flourishes. The address side of the mailer has a high-key value, while the opposite side is low key. This piece is given a special appeal by the use of an unusual shape and die-cut black flaps that lift up to reveal more information printed on a light screen of olive green.

The mailer, along with the rest of the identity system, uses three common colors—black, olive green and a metallic bronze—to establish a unity among the elements and give a common identity to the campaign.

This poster for Western Lithograph features a very stylized image of a man riding a registration mark as if it were a bull. Note the simplicity of the basic design. This straightforward, asymmetrical design utilizes extremes in contrast in many ways. One type of contrast is provided by the colors used—black and fluorescent orange printed on a white paper. Flat shapes of color are unified and given depth by the dotted background behind the upper half of the figure; this use of gradation adds dimension to the poster while maintaining a stylized graphic feel.

The relative size of the elements also provides an unexpected contrast. Normally a registration mark would be very small. By virtue of its size in this design, however, it takes on a life of its own. With a tilt and the addition of a rider, it becomes a bucking bull in a graphic rodeo. The type on the poster takes a back seat to the images, which is perfectly acceptable for this format. If you can draw the viewer into the poster and arouse curiosity about the concept, your type will be read.

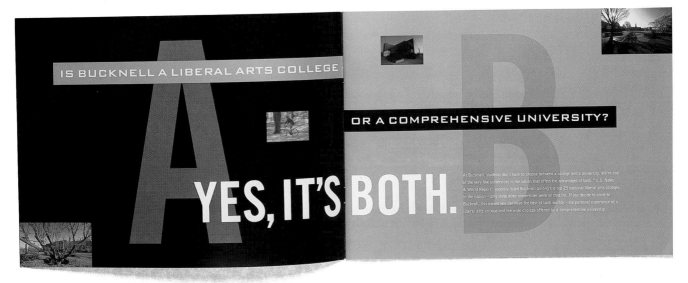

The concept behind this piece is that students typically have two choices as to what kind of educational experience they want from a college: a small liberal arts college or a larger university with more academic choices. This brochure promotes Bucknell as a place where students can have the best of both worlds. Because the heart of the concept is a comparison between two very different choices, contrast played a natural part in creating this design. By giving both choices a distinctive look, the concept is easily communicated.

Contrast is provided throughout the layout, with the two sides of each spread using elements that are direct opposites of one another. For example, one page has a dark background, the fac-

ing page has a light background; one typographic page is exactly the opposite color of the page facing it. Despite these contrasts, there is also a certain amount of unity in the design, supporting the idea of Bucknell as a college that offers students the best of both educational choices. For example, the same typefaces are used on both sides of each spread, and shapes and words often continue uninterrupted (except by color changes) across the gutter. The horizontal format allows the design to be broken in half vertically and still leaves enough room to develop the graphics.

Unity

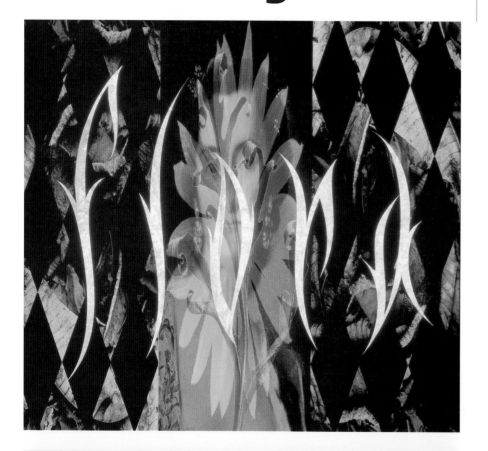

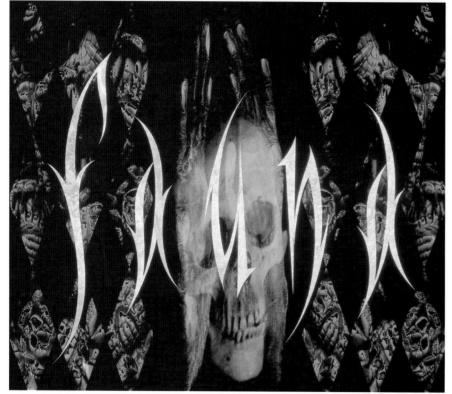

These two pieces successfully combine several elements that work very closely together: type, shape and textures. The typeface, which the designer hand-rendered herself, is very linear and functions somewhat as type and somewhat as line at the same time. In addition to this multipurpose element, there are a number of other elements, all of which are blended with skill and which work together to create a mood. Though the images could work separately, they are even more powerful combined with one another.

How is unity achieved? For one thing, the basic design of both pieces is the same: A single word (and notice how the two words chosen are quite similar) is placed over a very textural, dreamlike collage of images. The overall value scheme for both pieces is identical, which also gives them unity with one another. Unity can be achieved through relating even very different design objects; here, for instance, using the diamonds in the background causes the diverse images to take on a definite communality, and achieves unity within each piece.

U n i t y

This self-promotional gift package consists of lots of bits and pieces, such as washers, bolts, wooden parts, twine, pipe, glue and even feathers, which the recipient is encouraged to use in constructing a toy. The challenge with this piece was twofold: First, the design needs to create a feeling of unity among the many different (but interrelating) pieces to be used in constructing the toy. Second, the entire three-dimensional package needs to feel unified and relate to its contents.

What is especially enjoyable about this piece is the sheer diversity of the elements. Unity is achieved in that all of the pieces provided are compatible enough in size and structure that they may be put together to create something. This piece wouldn't work, for example, if the apparently random elements were *truly* random to the point that they couldn't be joined together. (Think of the confusion if all of the nuts provided were too big for all of the bolts.)

In a way, this piece is the epitome of the design process—elements that might appear on the surface to be unrelated are gathered and combined in a format (in this case, a cylindrical container) to give them a kinship.

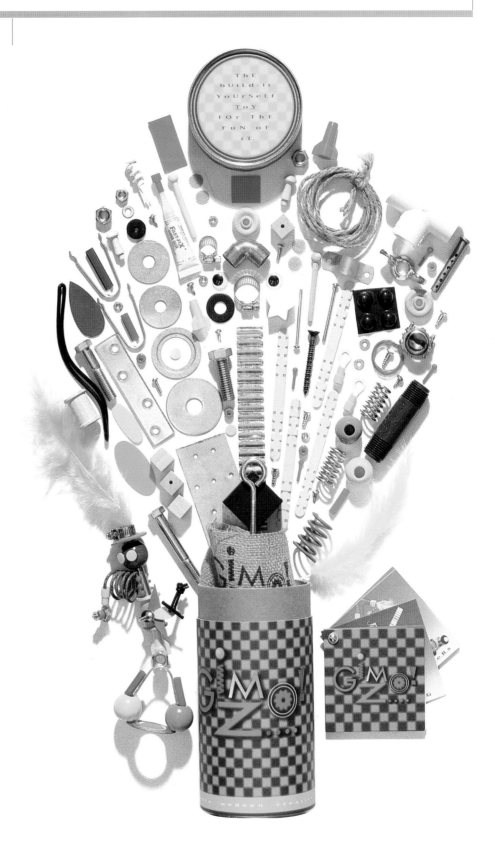

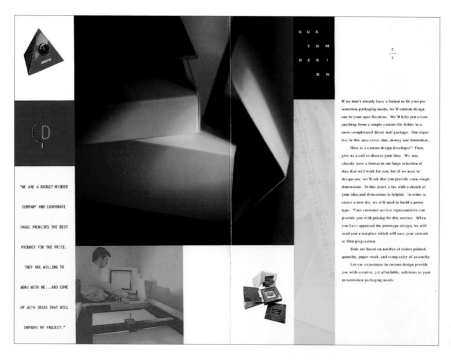

This brochure introduces many kinds of elements. Along with sophisticated studio photography, the designer incorporated several typefaces, color shapes, product shots and technical drawings. The result is a very interesting brochure that holds together remarkably well, in part because the designer skillfully uses color to unify the design.

I counted over a dozen different flat colors that appear and reappear in this design. How do so many colors help achieve unity? Despite the relatively large number of colors, they hold together because they all have roughly the same intensity (or value) and they are all essentially compatible with one another.

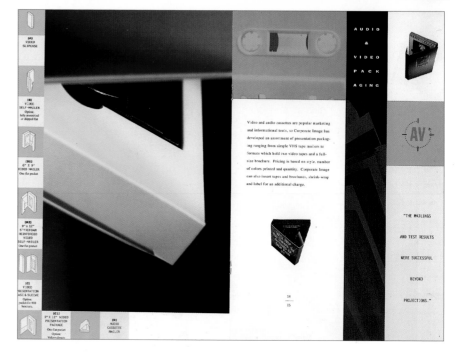

In addition, certain colors reappear in different parts of the layout, and the eye begins to remember the palette, even though it is large.

Equally important, the brochure is based on a simple, but easily recognizable, underlying grid, and this grid is followed rather strictly. In some cases a very tight grid can be deadly to a design, but in a piece with this many different elements, the grid helps provide unity.

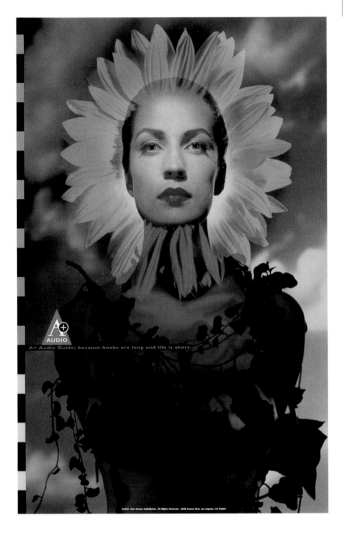

In creating these posters, the designer worked on the computer to seamlessly blend photos with very different subject matter into a surreal, two-part image centered around the front and back of a woman. The parts of each image are held together by unifying graphic elements—in particular, the use of color.

In the poster showing the woman's back and spine, the woman's body uses primarily golden tones, the spine image is electric blue, and those two images are surrounded by red roses—essentially a color palette using shades of red, yellow and blue, the

three primary colors. In the poster showing the woman's face, peach and orange tones are used for the face and the glow around it, and these colors are surrounded by a purple sky. Both the orange and the purple are complementary colors (colors composed by mixing two primaries).

The red logo works equally well on both posters, and provides an example of red used as a neutral color that goes well with both color palettes.

This poster is one of a series done to remind students at Brigham Young University of approaching registration deadlines. The design employs simple, straightforward typography and an illustration that's full of various lines and shapes, creating a feeling of great movement and activity. The unifying aspects of the design are the repetition of certain colors, the weight of lines used to trap these colors, and visual icons such as clouds, shrubs and stars. (The clouds and stars, which float throughout the illustration, tend to pull it together through their repeated use; the shrubs provide a frame that gives the illustration stability.)

Consider also the way color is used. The blues and greens fall primarily on the focal points of the illustration, while accent colors are scattered over the image to create a pleasing balance and unity. Notice how the orange appears sporadically throughout the illustration.

See how the illustration is swimming in white paper? Some might consider making the image much larger in the format, but the generous white space actually adds elegance and balances the feeling of activity and busyness in the illustration itself.

Michael Cronan, Lisa Van Zandt, Geordie Stephens
Cronan Design

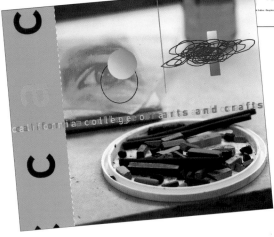

This catalog for an art school naturally combines different elements suggestive of the visual arts. For example, the illustrations bounce back and forth between abstract and realistic paintings, architectural and facilities photography, sculpture and industrial design, and so on. All of these illustrations are tied together successfully by repeating typography, color solids and page structure.

For example, type runs vertically in several places in the design; the book would seem fractured if it appeared this way only once. The same large typeface is seen in numerous places; when that typeface is knocked out of a photograph, the photograph is united with the typography. The same goes for repeated colors and key grid lines. Consequently, while the variety of elements is great, the design still feels cohesive.

Almost any multipage document will benefit from a design done with an eye to unity, but unity is particularly important in a catalog, since the nature of a catalog is to promote multiple offerings or products from the same institution. These various offerings may be quite different, but should appear to be connected since they come from the same place.

Color & Value

Earth Technology Annual Report
Lana Rigsby
Rigsby Design

This beautifully colored annual report uses photographic duotones, each a mixture of black and one of seven PMS colors, then printed on frosted acetate. These translucent photo pages then overlay pages of large text reversed out of compatible solid PMS colors.

Although there is no use of four-color process, the duotones combined with the solid colors give the design a very lively look. Because these duotones use saturated color, they are fairly low key (darker in tone), which creates an intriguing contrast against the white of the paper on opposite pages. Additional contrast is provided by the use of small serif text type on the white pages and large sans serif type on the color pages.

The design readily communicates the environmental concerns of the company through the use of natural photography and landscapes. While the photography is splendid, the bright solid colors add additional snap to the design. These colors aren't at all earth tones, which might be the expected solution; instead, they are vibrant, saturated colors that draw the eye to the key messages printed on them.

This promotional poster (and the handy paper bag carryalls) are printed on the natural brown paper of an actual feed bag. This color is used for effect as a backdrop for the several Pantone inks. To ensure that the values of the piece will all automatically be somewhat close, there are no tones whiter than the color of the paper, and the ink colors chosen for the piece are also mid-range in value (that is, no very dark colors, such as black, are used).

The colors that were chosen are shades of orange, green and purple—all secondary colors (opposite primary colors) on the color wheel. In other words, green is made of two primaries (yellow and blue), purple is made of the primaries red and blue, and orange is made of red and yellow. For this reason, the colors seem very compatible, especially when coupled with the muted tone of the paper bag, and provide an appropriately subtle effect for promoting an art event held outdoors in a park.

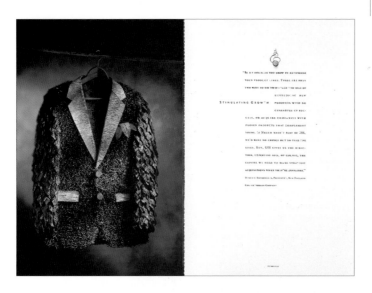

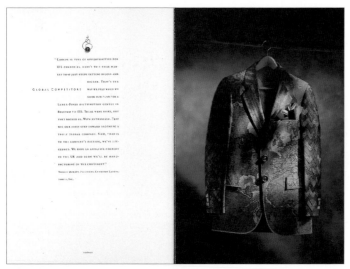

I included this piece for several reasons. Not only is the design simple and elegant, but it also provides an excellent example of a great contrast in values used effectively: darker-valued full-page photographs work well with lighter-valued text pages. Each of the shots (including the photograph of the officers) uses the same painted canvas background, which instantly unifies the design and enhances the mood. The suitcoats and suitcoat hangers, used as props in nearly every photo, are unifying elements that serve to tie all the photo pages together. The text pages are handled simply and consist of just two ink colors (brown and green) printed on a cream-color stock. These type colors are compatible with the photo pages because they're pulled from tones in the photography.

The suitcoat props are one of the most interesting aspects of the book. Each of the coats was created to illustrate an idea, such as "Global Competitors" and "Executive Resources." This concept is carried effectively throughout the design through similar treatment of one important idea on each spread. Attention is given to even the smallest details to reinforce the concept, and anything that might detract from the concept is removed.

The four muted metallic colors on the cover of this brochure create a handsome backdrop for the black title box with its very simple title reversed out to white. Since the brochure is driven by the use of four-color product photography, including some dramatic close-ups, the text pages are very simply done in black and white. The typeface used is Courier (considered a default font in some word processing applications) and so calls relatively little attention to itself.

The designer decided to place white type on a black background, which gives the book a sleek appearance and also enhances the photographs on each facing page. As a subtle way to unify the pages, the cover of this piece uses a very structured grid that is vaguely echoed inside the brochure by the subject matter of the photography.

Texas Instruments Poster
Jan Wilson, Bryan Peterson
Peterson & Company

This poster was designed to appeal to children in grades four through six and to spark their interest in math while at the same time introducing them to calculators designed and manufactured by Texas Instruments.

The piece provides an excellent example of intense color used to attract a particular audience—in this case, children. Given the instructional nature of the poster, the design is necessarily complex so that many of the math topics taught to this age group can be included. In addition to this complexity of subject matter, lots of different colors are also used to keep the poster appealing to its audience. But even though there are many colors in the poster, it's still unified by restricting those colors to a palette (a set range of colors that work together). The color palette here, for example, is primarily bright colors that are bent slightly to the pastel side. These somewhat muted colors blend nicely together while still giving the design a vibrant feel.

The concept of this design depends primarily on the drama of the image of clenched hands and type, but this CD cover would not be successful without the use of color. The warm tones, in conjunction with the image, suggest a feeling of caring and love. The background of the piece is by necessity dark, to accentuate the glow of the hands. Imagine how the impact would have been affected by a white background. The viewer is left to imagine what (if anything) is being grasped by the hands. What is particularly appealing about this cover is its simplicity.

Note the placement of the type. A less imaginative designer might have placed the type adjacent to the illustration, but using it as a working element with the photo image gives the design added power and unity.

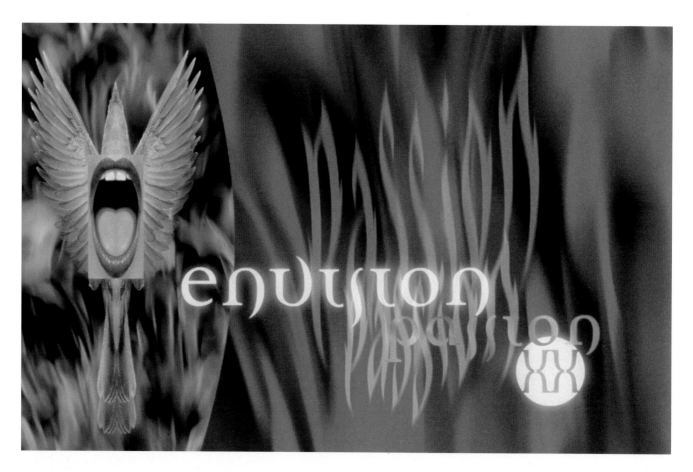

This poster, created for the 20th Envision design conference, was designed to convey the concept (and feeling) of passion, which was the theme of the conference. Notice how the hot red colors, which are naturally suggestive of passion, are repeated throughout the design, including on the tongue, in the flames, and for most of the background.

The white-hot glow of the "envision" type immediately draws the eye to the name of the conference, the focal point of the poster. The word "passion" is given less emphasis, and is even played down with colors that are similar to the rest of the art. Notice, too, how the word "passion" overlaps the XX type, automatically uniting the theme of the conference with its title. All of the type is designed to echo the flames in the photograph, so that these two inherently different elements (type and photograph) are unified by similar treatments.

This brochure uses many design principles and elements well. You have the textures behind the type, the contrast of white against dark, and an effective use of line, type and shape. But what most intrigues me about the piece are the subtle shifts of value that carry the design.

For example, the cover is very low key; that is, darker values are used almost exclusively. But within this relatively small range of values the designer establishes the structure of the brochure through subtle delineation of a grid that is carried out throughout the brochure. In addition, the designer had the foresight to have the photos shot with the same textures, and conveying the same mood, as the rest of the piece. The diagrams (illustrations of workstations, for example) naturally work best on a white background, while the type and photography are nicely framed within the dark sections.

Credits

Credits listed are in addition to the credits accompanying the art on the page. All pieces were used by permission of the design firm.

Alexander Isley Design: p. 105 © Alexander Isley Design.

Cronan Design: p. 94, 103, 113 and 131 © Cronan Design. p. 131, photographers: Joel Puliatti, Neil Hoffman, Michael Cronan.

Geer Design: p. 85 © 1995 Geer Design, Inc.; art director/ designer: Mark Geer, photographer: Key Sanders, client: The Stone Kitchen; p. 99 © 1995 Geer Design, Inc; art director: Mark Geer, designers: Mark Geer and Mandy Stewart, copywriter: Debra K. Maurer, photographer: Chris Shinn, client: South Texas College of Law; p. 114 © 1994 Geer Design, Inc.; art director/ designer: Mark Geer; photographer: Beryl Striewski; client: Justice Records; p. 124 © 1993 Geer Design, Inc.; art director/designer: Mark Geer, client: Western Lithograph.

Greteman Group: p. 102 © Greteman Group; p. 116 © Greteman Group.

Hornall Anderson Design Works, Inc.: p. 93 © Hornall Anderson Design Works, Inc. and The Frank Russell Company; art director/ designer: Jack Anderson; designers: Lisa Cerveny, Suzanne Haddon; p. 111 © Hornall Anderson Design Works, Inc. and Starbucks Coffee Company; art director/designer: Jack Anderson; designers: Julie Lock, Bruce Branson-Meyer, Mary Chin Hutchinson; illustrator: Julia LaPine; p. 139 © Hornall Anderson Design Works, Inc. and Watson Furniture Company; art director/designer: Jack Anderson; designers: Mary Hermes, Leo Raymundo; illustrator: Yutaka Sasaki; photographer: Robin Bartholick.

The Kuester Group: p. 98 © 1992 Potlatch Corporation; p. 121 © 1994 Pentair Inc.; p. 134 © 1992 UIS, Inc., New York.

The Office of Eric Madsen: p. 86 © Weyerhaeuser Paper Company; art director/designer: Eric Madsen; photographer: Terry Heffernan; design firm: The Office of Eric Madsen; client: Weyerhaeuser Paper Company; printer: Bradley Printing Company; p. 95 © Crane Business Papers; art director/designer: Eric Madsen; illustrators: Lynn Schulte, Kim Feldman; design firm: The Office of Eric Madsen; client: Crane Business Papers; printer: Fine Arts Engraving Company.

McRay Magleby, BYU Graphics: pp. 80, 84, 89, 112 and 130 © BYU Graphics.

Margo Chase Design: p. 97 © 1994 Margo Chase Design; p. 117 © Margo Chase Design; p. 126 © 1992 Margo Chase Design; p. 137 © 1994 Margo Chase Design; p. 138 © 1994 Margo Chase Design.

Pattee Design, Inc.: p. 82 © Pattee Design, Inc.; photography: Russ Widstrand; writer: Mike Condon; client: Central Resource Group; p. 92 © Pattee Design, Inc.; photography: King Au; writer: Mike Condon; client: Fox River Paper; p. 101 © Pattee Design, Inc.; photography: Pierre-Yves Goavec; writer: Mike Condon; client: Decisionmark Corp.; p. 106 © Pattee Design, Inc.; client: Metro Waste Authority; p. 128 © Pattee Design, Inc.; photography: Perry Struse; writer: Jean O'Neill; client: Corporate Image.

Peterson & Company: pp. 88, 91, 109, 122, 125 and 136 © Peterson & Company.

Richardson or Richardson: p. 108 © 1988 Phoenix Fire-Pal; p. 135 © 1995 Unitech Industries.

Rigsby Design: p. 110 © 1993 Rigsby Design; art director: Lana Rigsby; designers: Lana Rigsby, Troy S. Ford; writers: Steve Barnhill, Melissa Landrum; photographer: Arthur Meyerson; illustrator: Andy Dearwater; design firm: Rigsby Design, Inc.; printer: Emmott-Walker Printing; client: Zoological Society of Houston; p. 120 © 1993 Rigsby Design; art director: Lana Rigsby; designers: Lana Rigsby, Troy S. Ford; writer: JoAnn Stone; photographer: Gary Faye; design firm: Rigsby Design, Inc.; printer: Emmott-Walker Printing; client: Earth Tech; p. 132 © 1994 Rigsby Design; art director: Lana Rigsby; designers: Lana Rigsby, Troy S. Ford; writer: JoAnn Stone; photographer: Gary Faye; design firm: Rigsby Design, Inc.; printer: Heritage Press; client: Earth Tech.

Sayles Graphic Design: p. 104 © 1993 Sayles Graphic Design; p. 133 © 1994 Sayles Graphic Design.

Sommese Design: pp. 81, 83, 87 and 119 © Sommese Design.

Van Dyke Company: pp. 100, 107, 115 and 118 © Van Dyke Company.

Vaughn Wedeen Creative: p. 90 © 1993 Vaughn Wedeen Creative; p. 127 © 1994 Vaughn Wedeen Creative; hand-lettering: Nicky Ovitt.

Vrontikis Design Office: p. 96 © Vrontikis Design Office; copywriter: Victoria Branch; p. 123 © Vrontikis Design Office; designer: Kim Sage; p. 129 © Vrontikis Design Office; designer: Kim Sage, photographer: Scott Morgan.

Index

More Great Books for Knock-Out Graphic Design!

Fresh Ideas for Designing With Black, White and Gray—Push the limits of limited color as you discover practical ideas and powerful inspiration for today's designer. Over 200 energetic designs will have you exploring the creative possibilities of black, white and all the shades in between. *#30745/$29.99/144 pages/50 color/185 b&w illus.*

1998 Artist's & Graphic Designer's Market—This marketing tool for fine artists and graphic designers includes listings of 2,500 buyers across the country and helpful advice on selling and showing your work from top art and design professionals. *#10514/$24.99/786 pages*

Graphic Design Basics: Pricing, Estimating & Budgeting—Make money with confidence using simple steps to boost the profitability of your design company and make things run a lot smoother. You'll learn money-managing essentials that every self-employed designer needs to succeed—from writing estimates to sticking to budgets. *#30744/$27.99/128 pages/ 47 color, 49 b&w illus.*

The Graphic Designer's Sourcebook—Find everything you need to run your business and to pull off your most innovative concepts. With names and phone numbers for more than 1,000 suppliers of unusual and everyday services and materials, this reference will save you hours of rooting for information. Listings include type, packaging, studio equipment, illustration, photography and much more! *#30760/$24.99/160 pages/18 b&w illus./paperback*

Fresh Ideas in Brochure Design—Make your design memorable with inspiration from this collection of cutting-edge sampling of today's best brochure design from 69 top studios around the country. *#30929/$31.99/160 pages/298 color illus.*

Graphic Design Basics: Creating Logos & Letterheads—Using 14 creativity-sparking, step-by-step demonstrations, Jennifer Place shows you how to make logos, letterheads and business cards that speak out about a client and pack a visual punch. *#30616/$27.99/128 pages/ 110 color, 125 b&w illus.*

Best Small Budget Self-Promotions—Get an inside look at the best of low-budget promotion with this showcase of more than 150 pieces that make clients stop and take notice. Included are examples of distinctive identity systems, unconventional self-promotions, pro bono work and more! Plus, you'll find costs and quantities, cost-cutting tricks and the story behind the designs. *#30747/$28.99/136 pages/195 illus.*

Getting Started in Computer Graphics—A hands-on guide for designers and illustrators with more than 200 state-of-the-art examples. Software includes Adobe Photoshop, Fractal Design Painter, Aldus FreeHand, Adobe Illustrator, PixelPaint and Micrografx Designer. *#30469/$27.95/160 pages/125 color, 25 b&w illus./paperback*

Creativity for Graphic Designers—If you're burned-out or just plain stuck for ideas, this book will help you spark your creativity and find the best idea for any project. *#30659/$29.99/144 pages/169 color illus.*

Getting It Printed—Discover practical, hands-on advice for working with printers and graphic arts services to ensure the down and dirty details like consistent quality, on-time output and effective cost control. *#30552/$29.99/208 pages/134 color, 48 b&w illus./paperback*

Designer's Guide to Marketing—Good design by itself isn't enough! Discover the key steps you must make to achieve the success your work deserves. Easy-to-understand marketing know-how to help you win clients and keep them. *#30932/$29.99/144 pages/112 color illus.*

Setting the Right Price for Your Design and Illustration—Don't price yourself out of work or vital income. Easy-to-use worksheets show you how to set the right hourly rate plus how to price a variety of assignments! *#30615/$24.99/160 pages/paperback*

Fresh Ideas in Promotion—Whenever you need a shot of creativity this knockout collection of everything from brochures and newsletters to packaging and wearables will bring you the freshest ideas for a variety of clients (and budgets)! *#30634/$29.99/144 pages/220 color illus.*

Graphic Edge—This bold international collection explores nontraditional ways of using type. Over 250 color images of typographic rebellions from top designers are presented. *#30733/ $34.95/208 pages/280 color illus./paperback*

More Great Design Using 1, 2, & 3 Colors—Make your ideas soar and your costs plummet. Dozens of ingenious examples will help you create great work without four-color expense. *#30664/$39.95/192 pages/225 color illus.*

Graphic Design Tricks & Techniques—Your quick reference to over 300 expert time- and cost-saving ideas from top studios. Get fantastic results in design, production, printing and more. *#30919/$27.99/144 pages/19 b&w, 99 color illus.*

The Best Seasonal Promotions—Get inspired with this exceptional collection of more than 150 fully illustrated promotions for every holiday and season of the year. Includes info on concept, cost, print run and production specs. *#30931/$29.99/144 pages/196 color illus.*

Graphic Artists Guild Handbook of Pricing & Ethical Guidelines, 9th Edition—You'll get practical advice on how to negotiate fees, the ins and outs of trade practices, the latest tax advice and more. *#30896/$29.95/328 pages/paperback*

Creating Great Designs on a Limited Budget—This studio manual, written by two authors who know design and its penny-pinching realities, shows designers how to create topflight work, even when the dollars are few. You'll discover how to create impact using only one or two colors, ways to get high mileage from low-cost visuals, thrifty ways to get jobs produced and many other money-saving tips. *#30711/$28.99/ 128 pages/133 color, 27 b&w illus.*

Quick Solutions to Great Layouts—Get your creative juices flowing with hundreds of time-saving ideas! You'll find sample cases with real-world solutions including full specs for newsletters, brochures, ads and more! *#30529/$28.99/144 pages/200 illus.*

Quick Solutions for Great Type Combinations—When you're looking for that "just right" type combination and you don't have the time or money to experiment endlessly, here are hundreds of ideas to create the mood you're after, including all specs. *#30571/$26.99/144 pages/ 175 b&w illus./paperback*

Graphic Design Basics: Creating Brochures and Booklets—Detailed demonstrations show you precisely how to plan, design and produce everything from a church bulletin to a four-color brochure. Plus, a full-color gallery of 20 well-designed brochures and booklets will give you loads of inspiration. *#30568/$26.99/128 pages/ 60 color, 145 b&w illus.*

Fresh Ideas in Letterhead & Business Card Design 2—A great idea-sparker for your letterhead, envelope and business card designs. 120 sets shown large, in color, and with notes on concepts, production and costs. *#30660/$29.99/144 pages/325 color illus.*

Fresh Ideas in Promotion 2—Volume 2 in this inspiring series of the best new work in promotion. Includes captions with concept, cost, print run and production specs. *#30829/$29.99/144 pages/160 color illus.*